PAINT 50 WATERCOLOUR FLOWERS

From basic shapes to amazing paintings in super-easy steps

Penny Brown

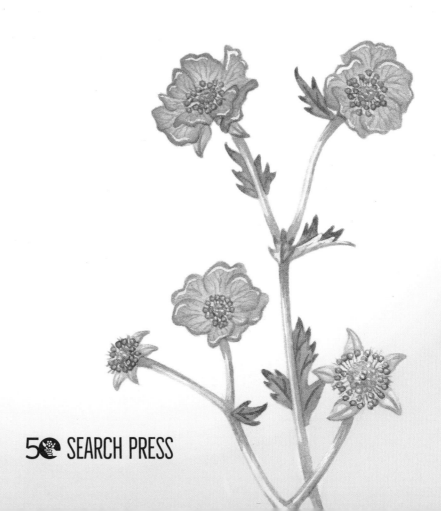

5❀ SEARCH PRESS

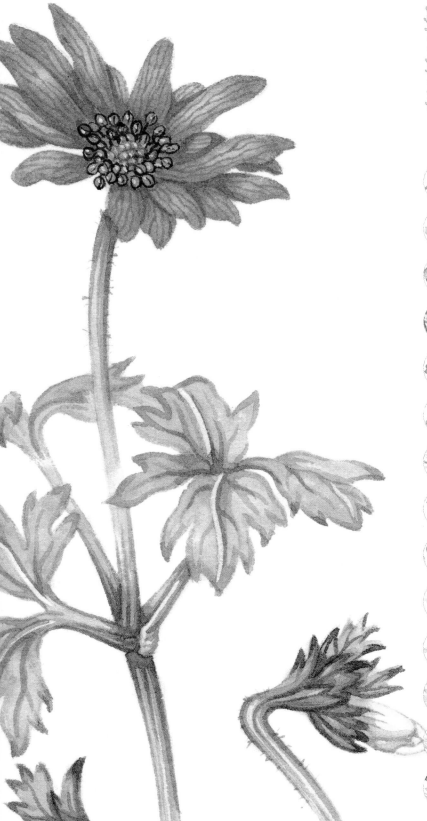

CONTENTS

Introduction

We are surrounded by a variety of flowers of the most astonishing colours and shapes, and drawing and painting them can be an absolute delight.

Think of the simple petal shapes of a daisy or a sunflower and contrast them with the complex structure of an orchid. Look at the tiny, ribbon-like petals of a witch hazel or the lush, extravagant curves of hibiscus. You will want to reach for your pencils to start capturing their shape and their detail.

And then, there is all that colour. All those gorgeous pinks of the rose petals, the deep reds and oranges of the bird-of-paradise flowers and the simple pale blues of the cornflower. The pure whites of the arum lily or the bright yellows of marigold petals will make you turn to your paints to revel in the rainbow of colours.

This book features familiar garden flowers, delicate wildflowers and extravagant exotics from all around the world. The projects will inspire you to look carefully at the structure of flowers and to observe their shapes, colours and details. Once you have drawn the flower, you will be shown how to apply initial washes, how to strengthen and blend the colours, and how to add details and finishing touches that will make your paintings come to life. The finished paintings can be framed or used to illustrate journals or scrapbooks. They will also make lovely greetings cards.

Practise these projects – the more you do, the more you will gain in skill and confidence, which will help you to draw and paint your own favourite flowers without the need for step-by-step diagrams.

Have fun.

Drawing

Each step-by-step project is accompanied by a full-size line drawing for you to copy onto your watercolour paper. You can work freehand to copy the painting or trace and transfer the image, as you prefer.

Use a sharp H pencil and light pressure, to ensure a faint line. The drawing should be only very faintly visible to ensure the best results – I suggest that you use an eraser to soften the lines still further before you begin.

You don't need much to get started – the essentials are a few pencils, an eraser and a good pencil sharpener. It's important to keep your pencils sharp to get a fine mark – this will help to keep your paint clean.

Extra line drawings

The line drawings are also available to download free from the Bookmarked Hub:
www.bookmarkedhub.com
Search for this book by title or ISBN: the files can be found under 'Book Extras'. Membership of the Bookmarked online community is free.

Materials for painting

Brushes

You need some small brushes with a fine point, preferably sable, for the projects in this book. I use a size 1 for the initial washes and 0 or 00 for details. I use another size 1 for blending and a separate small brush for gouache work.

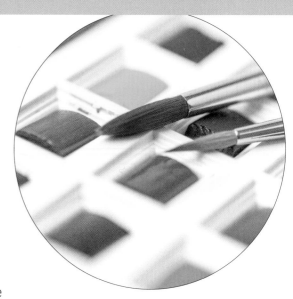

Paint

Watercolour paints are available in pans or in tubes. You can use whichever you prefer. I use pans as I find them easier to manage and less wasteful.

Watercolour brushes and pan paints.

Pans These are hard blocks of paint. To make them workable, use a damp brush to gently agitate the surface – this will load your brush. You can then transfer the wet paint to a palette, either for mixing, or to make larger or more diluted amounts of a colour.

Tubes Paint in tubes can be squeezed out directly onto your palette, ready to be diluted to the required strength.

Mix your colours with water on a palette (a white china plate will work well) to the strength you need for a particular area. A 'strong' mix has more paint, while a 'weak', pale mix has more water.

Watercolours dry lighter than they appear when wet, so practise creating washes – a layer of diluted colour – in different strengths on some spare paper before you begin.

Other materials

Paper Normal cartridge paper will buckle or 'cockle' when wetted, so you need to use watercolour paper. This is available with different surface textures, ranging from heavily textured surfaces, called Rough; to completely smooth, called HP or hot-pressed. Using smooth HP paper will give the best results for these flowers and that is what I use. The textures of Rough paper can be used to create interesting effects, but generally HP paper is more suitable for fine work.

Water I use two jam jars of clean water, one to wash brushes in and the other to dilute the paint with. Dirty water will affect your colours.

Kitchen paper I remove excess water and paint from my brush before applying it to the paper, by dabbing it on a piece of kitchen towel. It is easy to overload the brush, resulting in puddles on your paper, particularly when painting small areas.

Surface detail of HP watercolour paper.

Colours

Mixing too many colours can result in a muddy palette, so it's best to use pure colours where possible. Below are listed the colours I have used in this book – from the Old Holland range. Any good artists' quality watercolours will be fine: match the colours on this page to the colours that you have. Colours with the same name can look very different in a different make, so trust your eye.

The colours you need for each project are listed alongside the instructions. Ivory black (not pictured) is also used on occasion.

Yellows

Yellow ochre | Aureolin | Cadmium lemon yellow | Gamboge lake | Indian yellow-orange

Reds

Red gold lake | Cadmium red light | Cadmium red deep | Alizarin crimson lake | Carmine lake

Pinks and purples

Permanent rose | Quinacridone violet | Magenta | Bright violet | Dioxazine mauve | Violet grey

Blues

Indanthrene blue | Cyan | Cobalt blue | French ultramarine

Greens

Sap green | Golden green | Chromium oxide | Olive green | Green earth

Earths

Naples yellow reddish | Indian red | Burnt sienna | Sepia | Van Dyck brown | Payne's grey

Painting techniques

Watercolour techniques can be divided into two: wet into wet, where fresh paint is added to (or taken from) a wet surface; and wet on dry, where the paint is added once the previous layer has dried. Initial colour washes are laid down using wet into wet techniques, while wet on dry techniques are used to strengthen colours and add details.

For the projects, unless noted, allow the paint to dry between each stage.

Wet into wet techniques

Softening for highlights
Soften the edges of the initial wash with a damp brush before it dries. This will leave highlights on the petals and stems, bringing the painting to life.

Blending
Apply a second colour over part of the dry initial wash. While the second colour is still wet, use a clean, damp brush to achieve a smooth gradation of colour. Make sure your brush is not too wet.

Wet on dry techniques

Layering
Start with an initial pale wash (1). Next, strengthen that wash with a second layer, taking care not to cover all the first layer (2). Continue to add layers, strengthening the initial colour or adding new colours, until the colours are strong enough. Allowing each layer to dry before adding the next.

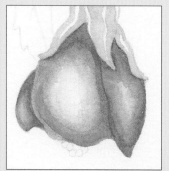

Glazing
Apply a glaze of clean water or a diluted wash of the original colour over dry areas to unify the paint work. A glaze of a new or contrasting colour will add subtlety or a glow to the finish.

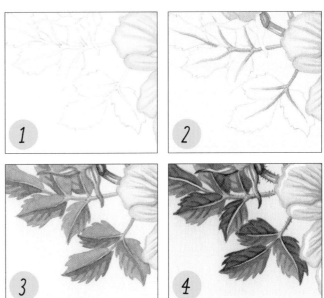

Lifting out

While a wash is still wet, highlights can be lifted out by gently touching the surface with a damp brush. The wet paint will be drawn into the brush and lifted away, leaving a pale area.

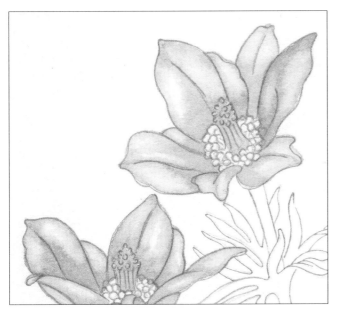

Leaving space

When applying washes wet in wet, paint non-adjacent areas (by skipping a petal, for example), or let adjacent areas dry before painting the next. This will prevent wet colours from bleeding together.

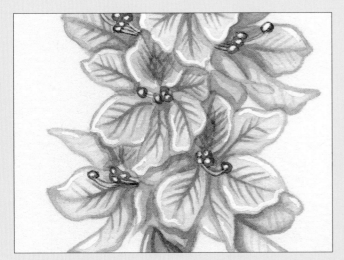

Fine details

The stamens and carpels in the flower centres are very variable in different flowers, and should be worked wet-on-dry for crisp results. Use watercolour or gouache and a size 00 brush, adding shadow and highlights to paint these details.

Using gouache

Gouache paint is opaque and can be painted on top of dry watercolour. Use it to add finishing touches such as leaf veins or tiny hairs. Add highlights to stems, stamens and petals with white gouache and a fine brush. Use yellow gouache to paint stamens or add a glow to stems and petals.

Simple botany

You don't need any experience of botany to paint flowers. However, it's handy to know some of the terms to help guide you when applying the paint.

Flowers With a huge variety in size, colour and shape, the flower's purpose is to attract pollinators to fertilize the plant to enable it to produce seeds.

Leaves Leaves absorb sunlight and, through photosynthesis, produce energy to feed the plant. The veins carry the water and food around the plant.

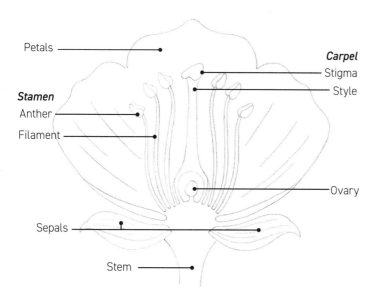

Petals

Carpel

Stigma

Style

Stamen

Anther

Filament

Ovary

Sepals

Stem

Structure of a typical flower

- *The **stem** supports the calyx, the outer part which protects the flower bud and is made up of **sepals**, which are adapted leaves.*
- *The **petals** are usually colourful, and often have lines or patterns to help insects find the nectar.*
- *The **stamens** are the male parts and consist of the **filament** and **anther**, which produces pollen.*
- *The **carpel** is the female organ, comprising the pollen-collecting **stigma** and the supporting **style**. The style provides a pathway for pollen to reach the **ovary**, which contains the seeds.*

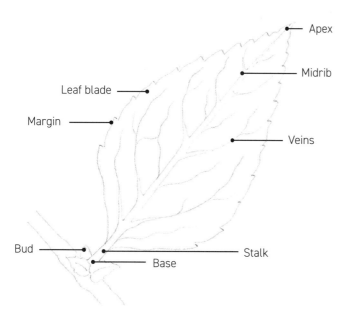

Apex

Midrib

Leaf blade

Margin

Veins

Bud

Stalk

Base

Structure of a typical leaf

- *A leaf will usually consist of a **stalk** and a flat **leaf blade**. The edges are called the **margin**, and the tip is called the **apex**.*
- *The central **midrib** is a continuation of the stalk and supports the leaf blade. Large and small **veins** branch from this to form a dense network that takes nutrients and water to all parts of the leaf.*
- ***Bracts** (not pictured) are modified leaves, sometimes brightly coloured.*

Troubleshooting

Finally, no matter how careful you are, mistakes will happen. Here are a few tips to allay some common concerns and help you correct your work if something goes wrong.

1. If the early stages of the painting look a bit loose and messy, do not worry. As you add darker washes and details, the painting will gain definition and strength.

2. Wobbly edges can be made crisper using a size 00 brush and quite dry paint.

3. Smudges can be lifted with a clean, damp brush – or you could add an additional element, such as a small bee, to hide them.

4. Gouache that looks too heavy can be softened or blended with a clean, damp brush, or can even be lifted off altogether.

Columbine

Drawing and colours

When drawing, it's easiest to add the stem of the central flower before adding the petals of the right-hand flower that overlap it.

The watercolour paints you need for this flower are: carmine lake, bright violet, aureolin, sap green, French ultramarine, cadmium red light, Indian red and dioxazine mauve.

You will also need white and yellow gouache paints.

Mixed colours

 STEM GREEN
Sap green and French ultramarine

 BOTANICAL GREY
Cadmium red light and French ultramarine

 RED SHADOW
Indian red and dioxazine mauve

Painting

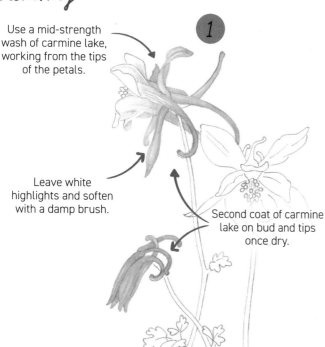

Use a mid-strength wash of carmine lake, working from the tips of the petals.

1

Leave white highlights and soften with a damp brush.

Second coat of carmine lake on bud and tips once dry.

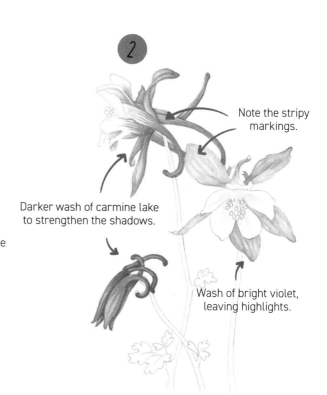

2

Note the stripy markings.

Darker wash of carmine lake to strengthen the shadows.

Wash of bright violet, leaving highlights.

3

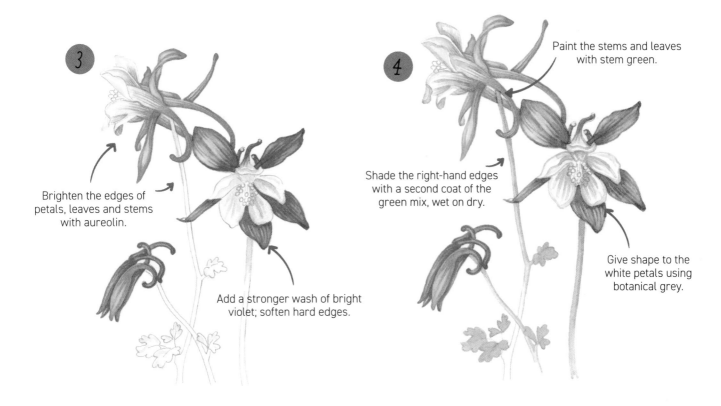

Brighten the edges of petals, leaves and stems with aureolin.

Add a stronger wash of bright violet; soften hard edges.

4

Paint the stems and leaves with stem green.

Shade the right-hand edges with a second coat of the green mix, wet on dry.

Give shape to the white petals using botanical grey.

5

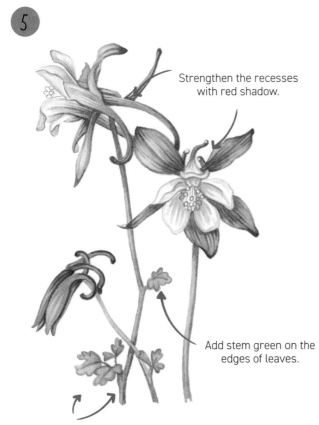

Strengthen the recesses with red shadow.

Add stem green on the edges of leaves.

Blend red shadow into the stems and leaf veins with a damp brush.

To finish, add touches of yellow gouache to the ends of the spur-like petals, leaves and stems, then add highlights with white gouache. Finally, outline the lower edges of each stamen with botanical grey.

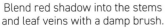

13

Snapdragon

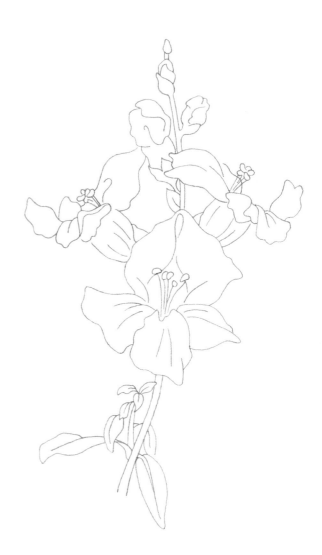

Drawing and colours

Draw the outlines of the petals before you add any markings or details.

The watercolour paints you need for this flower are: permanent rose, sap green, Naples yellow reddish, gamboge lake, cadmium red light, French ultramarine and Indian red.

You will also need white and yellow gouache paints.

Mixed colours

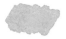 **BOTANICAL GREY**
Cadmium red light and French ultramarine

 STEM GREEN
Sap green and French ultramarine

 STEM SHADOW
Stronger sap green and French ultramarine

Painting

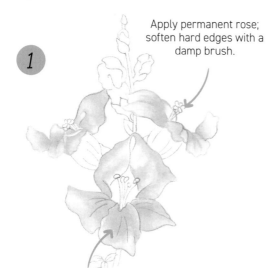

1

Apply permanent rose; soften hard edges with a damp brush.

Add a second layer wet on dry to areas of shadow to build the tone.

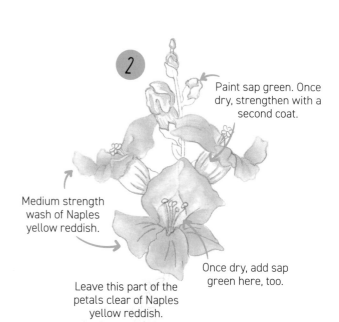

2

Paint sap green. Once dry, strengthen with a second coat.

Medium strength wash of Naples yellow reddish.

Leave this part of the petals clear of Naples yellow reddish.

Once dry, add sap green here, too.

3

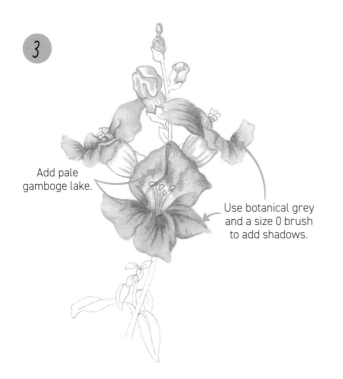

Add pale gamboge lake.

Use botanical grey and a size 0 brush to add shadows.

4

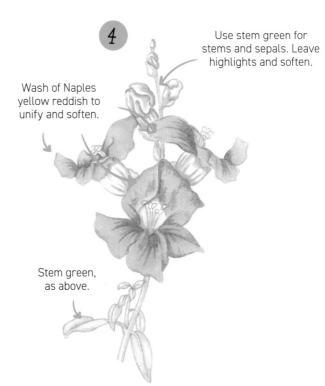

Use stem green for stems and sepals. Leave highlights and soften.

Wash of Naples yellow reddish to unify and soften.

Stem green, as above.

5

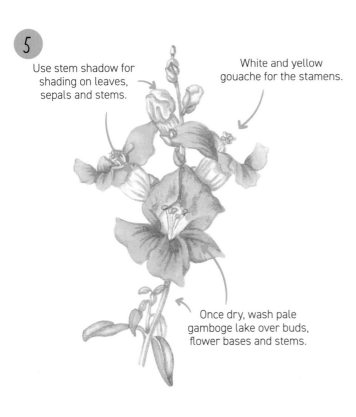

Use stem shadow for shading on leaves, sepals and stems.

White and yellow gouache for the stamens.

Once dry, wash pale gamboge lake over buds, flower bases and stems.

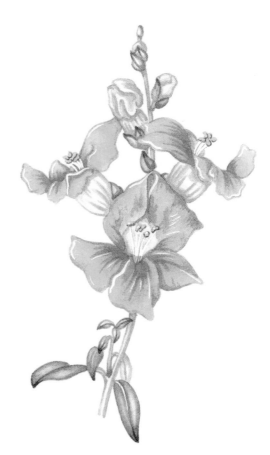

Add more depth of colour to the leaves and sepals with stem shadow. Use strong Indian red and a size 00 brush to outline the yellow stamens and add emphasis to the leaf tips. Finally, use white gouache to add highlights to the petals.

Indian Mallow

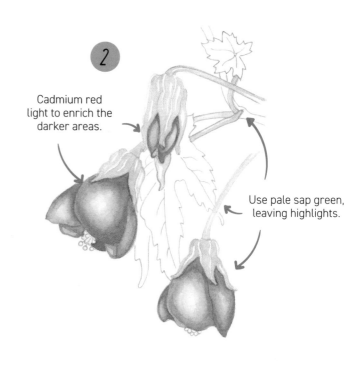

Drawing and colours

Take care to draw the sepals at the top of the flowers and buds accurately, as they are very characteristic of this plant.

The watercolour paints you need for this flower are: Naples yellow reddish, cadmium red light, dioxazine mauve, Indian red, sap green, green earth, cobalt blue, Indian yellow-orange and carmine lake.

You will also need white gouache paint.

Mixed colours

 WARM RED
Naples yellow reddish and cadmium red light

 WARM GREEN
Sap green and green earth

 COOL GREEN
Sap green and cobalt blue

 RED SHADOW
Dioxazine mauve and Indian red

Painting

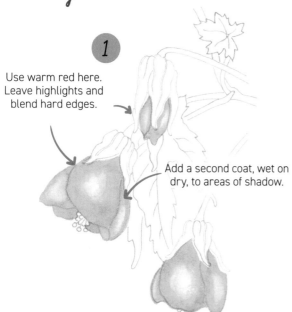

1

Use warm red here. Leave highlights and blend hard edges.

Add a second coat, wet on dry, to areas of shadow.

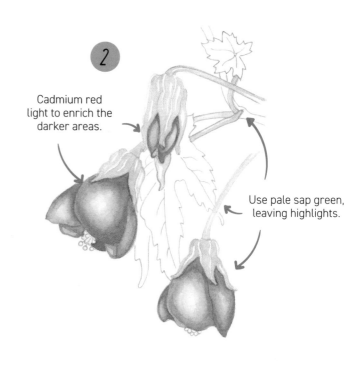

2

Cadmium red light to enrich the darker areas.

Use pale sap green, leaving highlights.

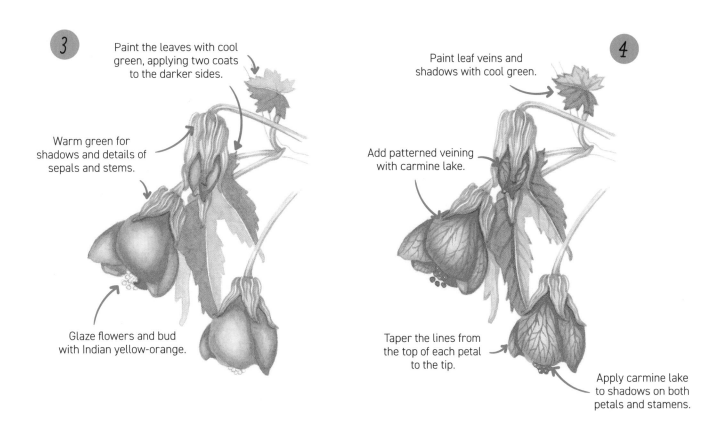

3

Paint the leaves with cool green, applying two coats to the darker sides.

Warm green for shadows and details of sepals and stems.

Glaze flowers and bud with Indian yellow-orange.

4

Paint leaf veins and shadows with cool green.

Add patterned veining with carmine lake.

Taper the lines from the top of each petal to the tip.

Apply carmine lake to shadows on both petals and stamens.

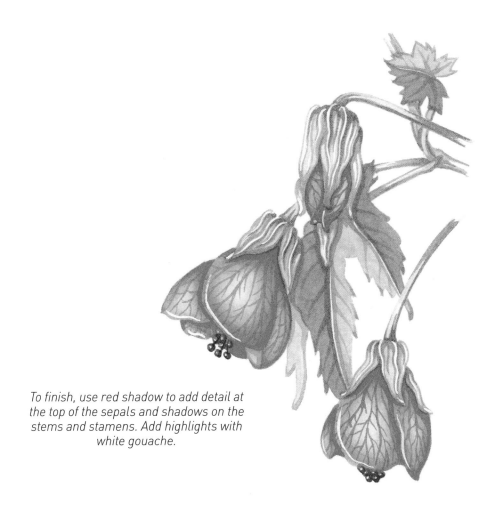

To finish, use red shadow to add detail at the top of the sepals and shadows on the stems and stamens. Add highlights with white gouache.

Camellia

Drawing and colours

When drawing, take your time with all the curves and indentations of the petal edges.

The watercolour paints you need for this flower are: permanent rose, cadmium lemon yellow, carmine lake, magenta, sap green, indanthrene blue, cadmium red deep, red gold lake, violet grey and magenta.

You will also need white and yellow gouache paint.

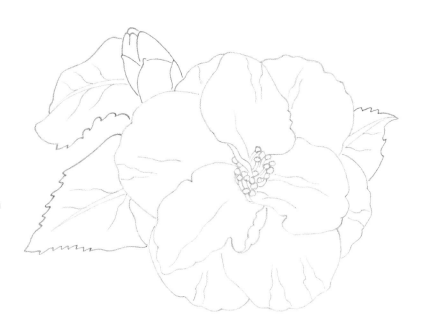

Mixed colours

 RICH PINK
Permanent rose and carmine lake

 NEUTRAL GREEN
Sap green and indanthrene blue

RICH PINK SHADOW
Permanent rose, carmine lake and magenta

NEUTRAL GREEN SHADOW
Sap green, indanthrene blue and cadmium red deep

Painting

1

Start in the centre of each petal and paint towards the edge, leaving a white margin.

Medium strength permanent rose.

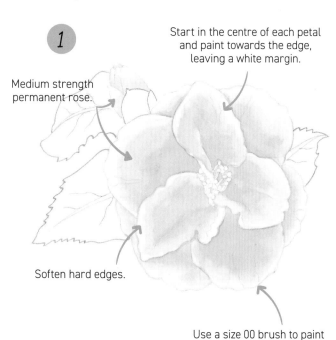

Soften hard edges.

Use a size 00 brush to paint pink around the stamens, and to outline each petal.

2

Paint the stamens with cadmium lemon yellow.

Glaze with rich pink, softening hard edges.

Add a second coat of rich pink to the centres, wet on dry.

3 Paint leaves and bud with two layers of neutral green.

Lift out highlights with a damp brush after each wash. On the second wash, lift out a larger area.

4 Add markings with neutral green shadow.

Once the markings are dry, apply a wash of neutral green shadow.

Add a small ellipse to each stamen with red gold lake.

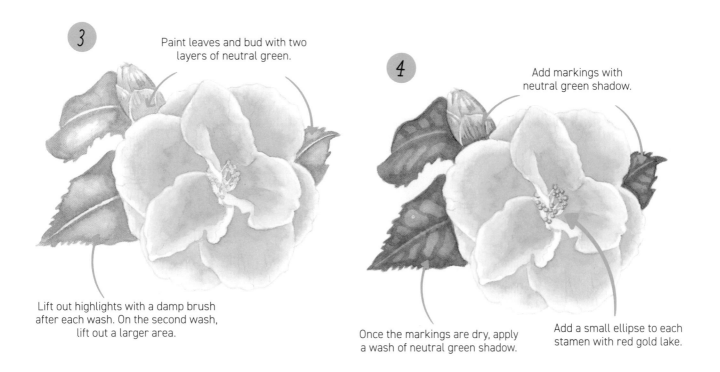

5 Add markings with rich pink and a size 00 brush.

Use stronger colour in the centres; let the markings fade and taper towards the edges.

Use violet grey to add shadows.

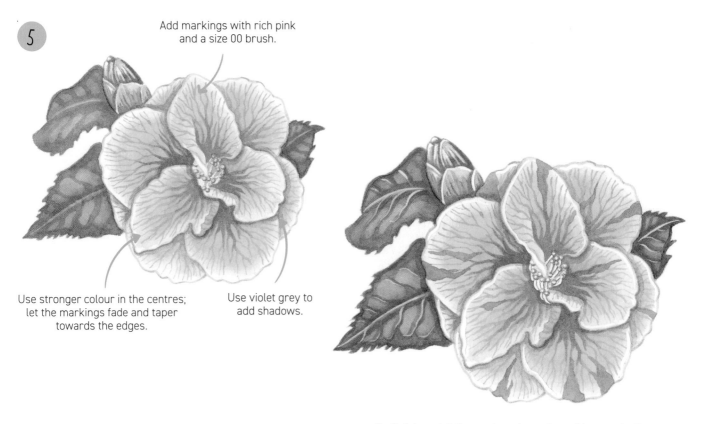

To finish, paint the wedge-shaped markings onto the petals with rich pink shadow. Use white gouache and a size 00 brush to paint the stems of the stamens, the veins on the leaves and to add white highlights to the petal edges.

Clematis

Drawing and colours

Keep the stems faint when drawing, so they can be erased wherever the leaves overlap them.

The watercolour paints you need for this flower are: bright violet, sap green, permanent rose, olive green, Indian red, quinacridone violet, alizarin crimson lake and van Dyck brown.

You will also need white gouache paint.

Mixed colours

 EARTHY GREEN
Olive green and sap green

 LEAF RED
Indian red and alizarin crimson lake

Painting

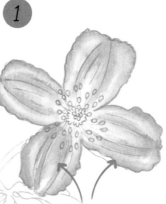

1

Pale wash of bright violet – leave white areas.

Apply paint in sections so you can soften edges before they dry.

Add a second coat to petal edges and middles, then soften.

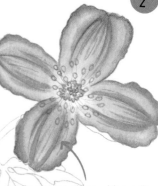

2

Add a coat of bright violet to strengthen the markings.

Use tiny circular marks of sap green for the centres.

Once dry, glaze with a pale wash of permanent rose, leaving a paler area around the centres.

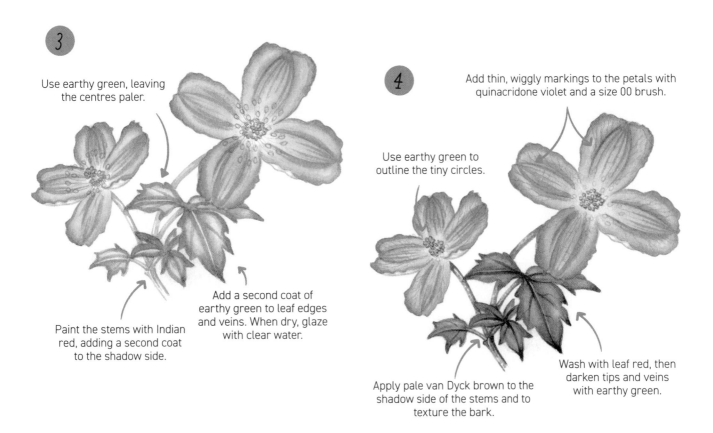

3

Use earthy green, leaving the centres paler.

Paint the stems with Indian red, adding a second coat to the shadow side.

Add a second coat of earthy green to leaf edges and veins. When dry, glaze with clear water.

4

Add thin, wiggly markings to the petals with quinacridone violet and a size 00 brush.

Use earthy green to outline the tiny circles.

Apply pale van Dyck brown to the shadow side of the stems and to texture the bark.

Wash with leaf red, then darken tips and veins with earthy green.

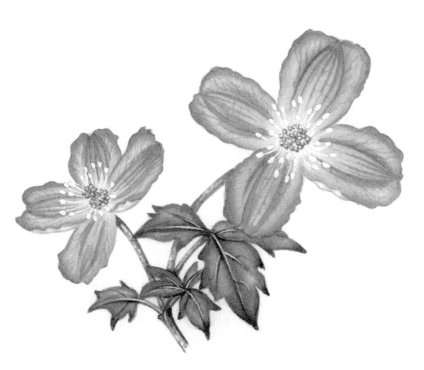

Lastly, paint the stamens with white gouache, making sure to curve the stems of the stamens differently, depending on the perspective. Add tiny white highlights to the green circles in the flower centres.

Coneflower

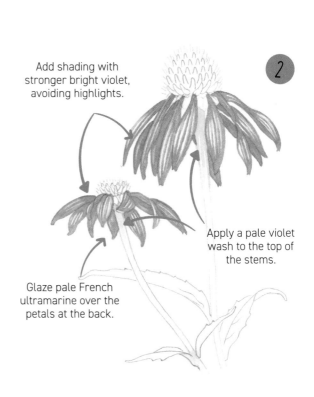

Drawing and colours

When drawing, it's a good idea to draw a faint initial guide line for the shape of the cones before developing them further.

The watercolour paints you need for this flower are: bright violet, French ultramarine, sap green, Indian yellow-orange, red gold lake, Payne's grey and cadmium red light.

You will also need white gouache paint.

Mixed colours

 STEM GREEN
Sap green and French ultramarine

 BLUE-VIOLET
Bright violet and French ultramarine

 GREY-BROWN
Cadmium red light, sap green and French ultramarine

Painting

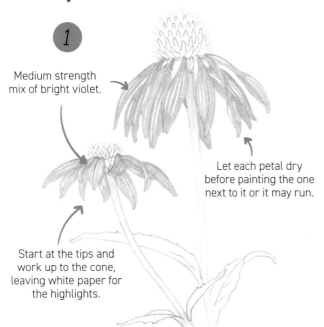

1

Medium strength mix of bright violet.

Let each petal dry before painting the one next to it or it may run.

Start at the tips and work up to the cone, leaving white paper for the highlights.

2

Add shading with stronger bright violet, avoiding highlights.

Apply a pale violet wash to the top of the stems.

Glaze pale French ultramarine over the petals at the back.

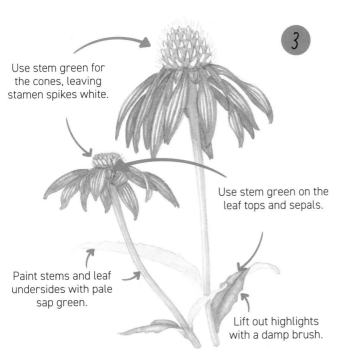

3

Use stem green for the cones, leaving stamen spikes white.

Use stem green on the leaf tops and sepals.

Paint stems and leaf undersides with pale sap green.

Lift out highlights with a damp brush.

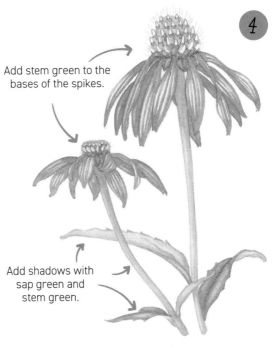

4

Add stem green to the bases of the spikes.

Add shadows with sap green and stem green.

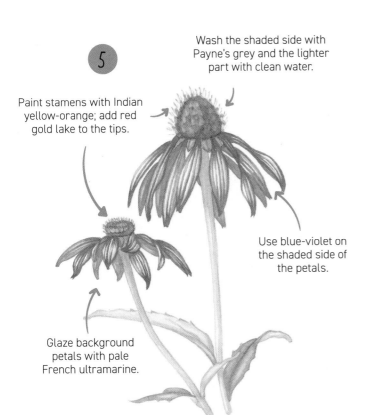

5

Wash the shaded side with Payne's grey and the lighter part with clean water.

Paint stamens with Indian yellow-orange; add red gold lake to the tips.

Use blue-violet on the shaded side of the petals.

Glaze background petals with pale French ultramarine.

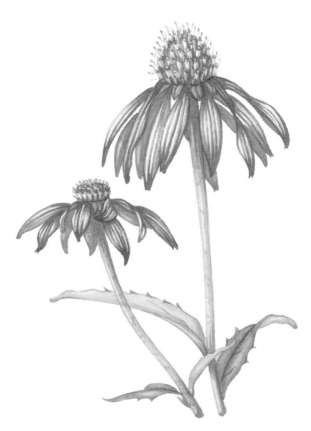

To complete the painting, use grey-brown to paint shadows at the top of the stems and add textural marks to the stems. Paint the veins with dark green. Mix white gouache with Indian yellow-orange and paint the stamens, adding more red gold lake to the tips and more white for highlights.

Perennial Cornflower

Drawing and colours

If you work freehand, take care to draw the stems faintly (or leave them out) where they will be overlapped by the leaves.

The watercolour paints you need for this flower are: French ultramarine, magenta, sap green, carmine lake and ivory black.

You will also need white gouache paint.

Mixed colours

PALE STEM GREEN
Dilute sap green and French ultramarine

STEM SHADOW
Stronger sap green and French ultramarine

Painting

Use French ultramarine for the frontmost petals.

1

Apply three coats, painting less of the lower parts each time.

Work from the tips and leave the bases unpainted, blending with a damp brush.

Darken the tips so foreground petals will stand out against petals behind them.

Use paler French ultramarine to paint the background petals in the same way.

2

Add pale magenta to the bases, and blend into the blue with a damp brush.

Keep background petals paler than foreground ones.

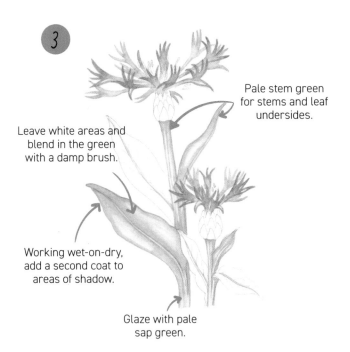

3

Leave white areas and blend in the green with a damp brush.

Pale stem green for stems and leaf undersides.

Working wet-on-dry, add a second coat to areas of shadow.

Glaze with pale sap green.

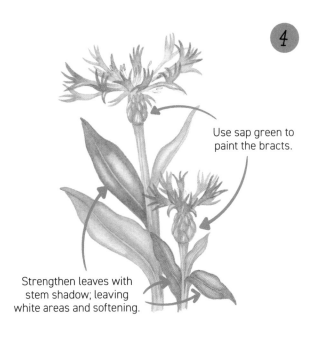

4

Use sap green to paint the bracts.

Strengthen leaves with stem shadow; leaving white areas and softening.

Add carmine lake to the base of the petals and strong French ultramarine to the tips, blending as before.

5

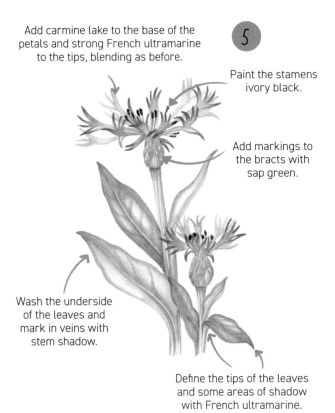

Paint the stamens ivory black.

Add markings to the bracts with sap green.

Wash the underside of the leaves and mark in veins with stem shadow.

Define the tips of the leaves and some areas of shadow with French ultramarine.

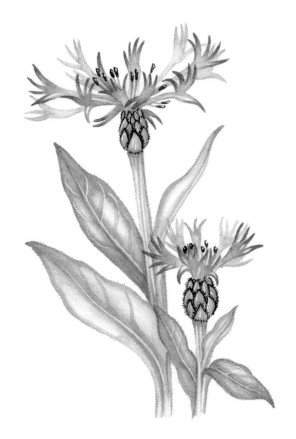

Draw black lines and tiny spikes around the bracts. Use white gouache to add highlights to the stamens and mark in some leaf veins. Finally, add tiny, irregular hairs to the stems and leaf edges with a sharp H pencil.

Crane's-bill

Drawing and colours

Erase the stem wherever it is overlapped by the leaves and seeds.

The watercolour paints you need for this flower are: cobalt blue, magenta, sap green, permanent rose, carmine lake, cadmium red light, French ultramarine, Indian red, golden green and ivory black.

You will also need white gouache paint.

Mixed colours

 MID BLUE
Cobalt blue and magenta

 STEM GREEN
Sap green and French ultramarine

 BOTANICAL GREY
Cadmium red light and French ultramarine

Painting

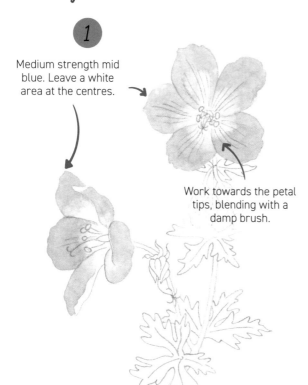

1

Medium strength mid blue. Leave a white area at the centres.

Work towards the petal tips, blending with a damp brush.

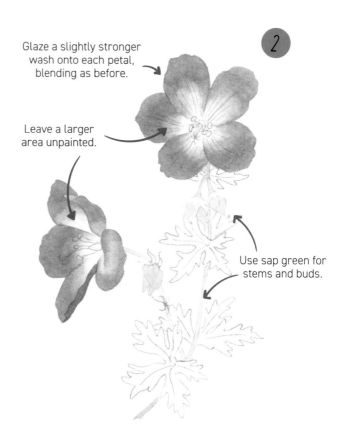

2

Glaze a slightly stronger wash onto each petal, blending as before.

Leave a larger area unpainted.

Use sap green for stems and buds.

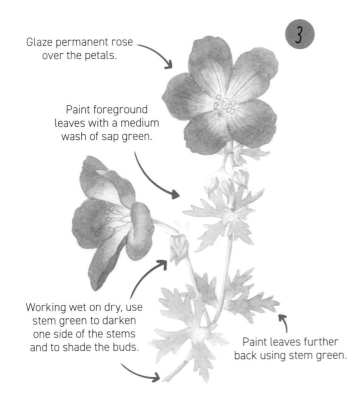

Glaze permanent rose over the petals.

Paint foreground leaves with a medium wash of sap green.

③

Working wet on dry, use stem green to darken one side of the stems and to shade the buds.

Paint leaves further back using stem green.

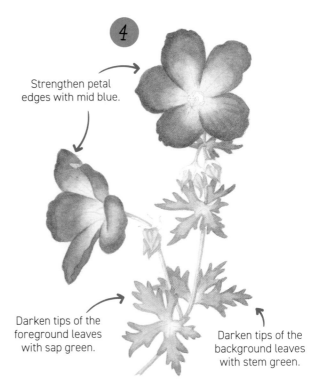

④

Strengthen petal edges with mid blue.

Darken tips of the foreground leaves with sap green.

Darken tips of the background leaves with stem green.

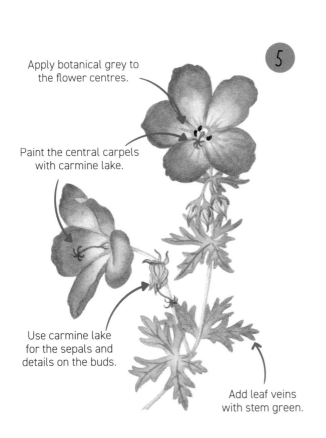

Apply botanical grey to the flower centres.

⑤

Paint the central carpels with carmine lake.

Use carmine lake for the sepals and details on the buds.

Add leaf veins with stem green.

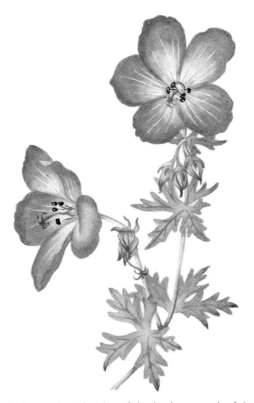

Use Indian red on the tips of the buds, some leaf tips and to add shadow to the stems. Paint the stamens ivory black. Use white gouache to add markings to the petals and highlights to the stamens. The ends of these markings can be softened with a damp brush and a dab of a tissue if they look too harsh. Add a touch of golden green to the leaf centres, the stems and the buds to add a glow.

Crocus

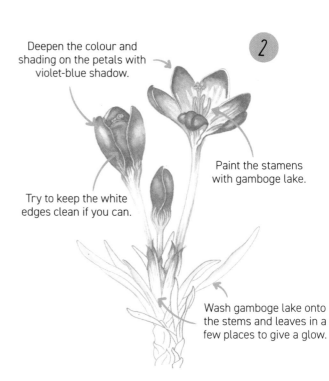

Drawing and colours

When painting, aim to keep the white petal edges clean as you work, but don't worry – smudges can be fixed in the final stage.

The watercolour paints you need for this flower are: cobalt blue, magenta, gamboge lake, sap green, cadmium red deep and red gold lake.

You will also need white gouache paint.

Mixed colours

 VIOLET-BLUE
Magenta and cobalt blue

 VIOLET-BLUE SHADOW
Stronger magenta and cobalt blue

 COOL GREEN
Sap green and cobalt blue

 COOL GREEN SHADOW
Sap green, cobalt blue and cadmium red deep

 DEEP RED
Magenta, cobalt blue and cadmium red deep

Painting

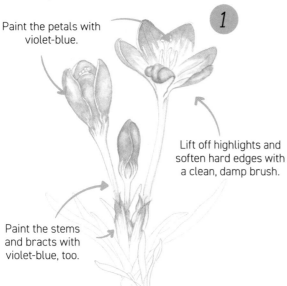

Paint the petals with violet-blue.

1

Lift off highlights and soften hard edges with a clean, damp brush.

Paint the stems and bracts with violet-blue, too.

Deepen the colour and shading on the petals with violet-blue shadow.

2

Paint the stamens with gamboge lake.

Try to keep the white edges clean if you can.

Wash gamboge lake onto the stems and leaves in a few places to give a glow.

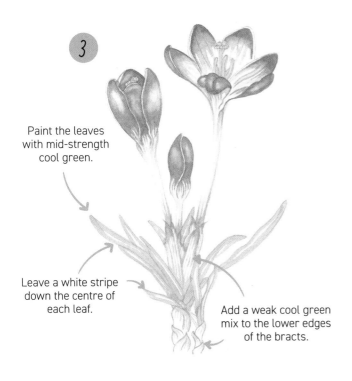

3

Paint the leaves with mid-strength cool green.

Leave a white stripe down the centre of each leaf.

Add a weak cool green mix to the lower edges of the bracts.

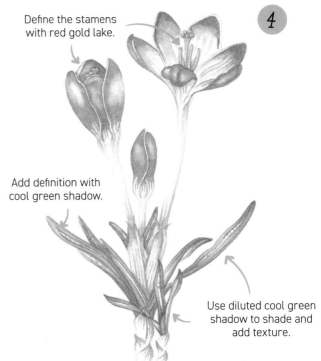

4

Define the stamens with red gold lake.

Add definition with cool green shadow.

Use diluted cool green shadow to shade and add texture.

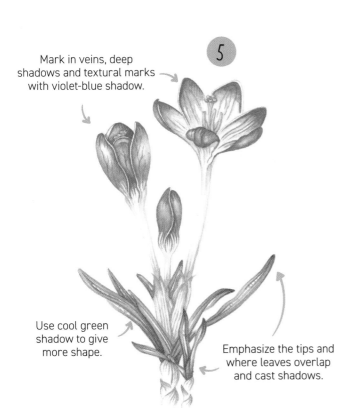

5

Mark in veins, deep shadows and textural marks with violet-blue shadow.

Use cool green shadow to give more shape.

Emphasize the tips and where leaves overlap and cast shadows.

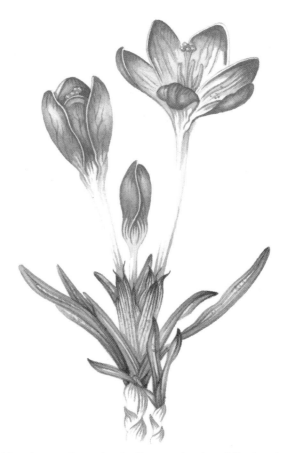

Use deep red to paint the lines at the tips of the bracts. Dilute the mix to add textural markings. Finally, use white gouache to add tiny highlights to the stamens and to neaten any smudged white edges on the petals.

Dog's Tooth Violet

Drawing and colours

The stronger yellow at the centre of the petals of this flower helps bees to find their pollen.

The watercolour paints you need for this flower are: cadmium lemon yellow, French ultramarine, cadmium red light, sap green, Indian red and gamboge lake.

You will also need white gouache paint.

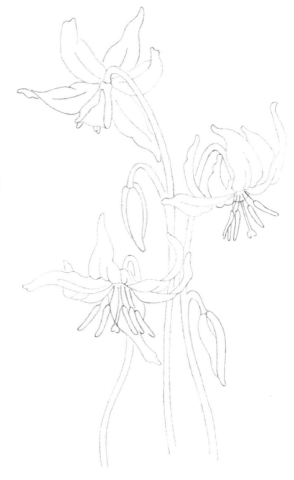

Mixed colours

 BOTANICAL GREY
Cadmium red light and French ultramarine

 STEM GREEN
Sap green and French ultramarine

 STEM SHADOW
Stronger sap green and French ultramarine

Painting

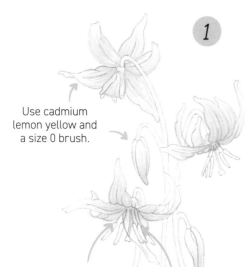

1

Use cadmium lemon yellow and a size 0 brush.

Petal inner surfaces are a darker yellow than the outer surfaces.

Add a second coat, wet on dry, to strengthen the colour. Take care not to cover all of the first coat.

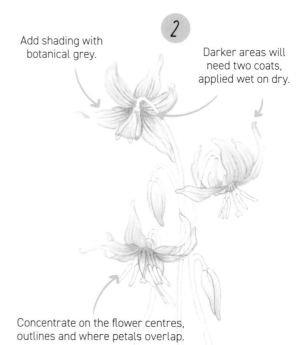

Add shading with botanical grey.

2

Darker areas will need two coats, applied wet on dry.

Concentrate on the flower centres, outlines and where petals overlap.

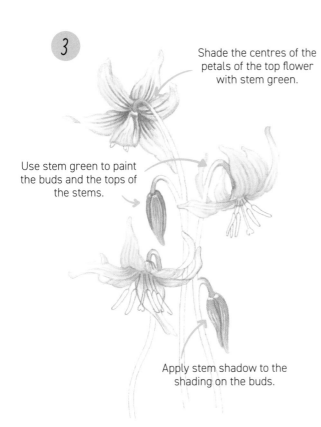

3

Shade the centres of the petals of the top flower with stem green.

Use stem green to paint the buds and the tops of the stems.

Apply stem shadow to the shading on the buds.

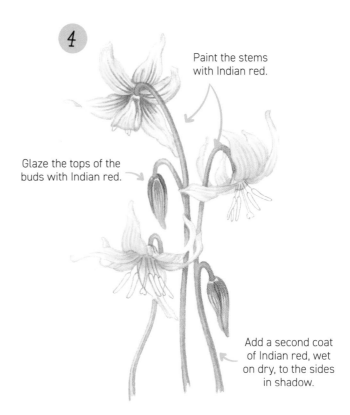

4

Paint the stems with Indian red.

Glaze the tops of the buds with Indian red.

Add a second coat of Indian red, wet on dry, to the sides in shadow.

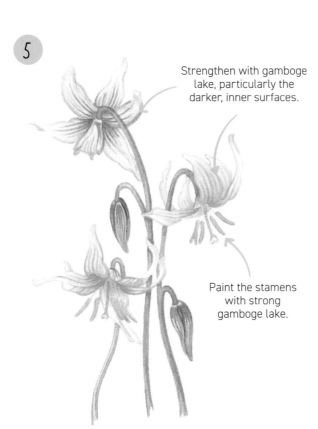

5

Strengthen with gamboge lake, particularly the darker, inner surfaces.

Paint the stamens with strong gamboge lake.

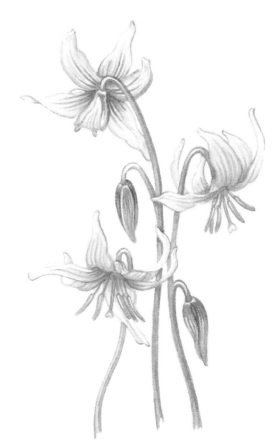

Add highlights to the petals, stems and stamens with white gouache. If necessary, strengthen areas of shadow with more botanical grey.

Early Spider Orchid

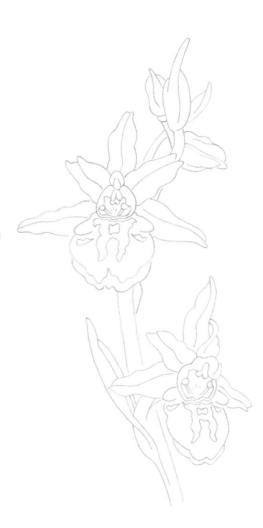

Drawing and colours

Draw the main shapes of the petals and flower centre before adding the details.

The watercolour paints you need for this flower are: sap green, French ultramarine, cobalt blue, cadmium lemon yellow, aureolin, Indian red, dioxazine mauve, burnt sienna and indanthrene blue.

You will also need white gouache paint.

Mixed colours

 STEM GREEN
Sap green and French ultramarine

 RED SHADOW
Indian red and dioxazine mauve

 DEEP YELLOW
Aureolin and burnt sienna

 DEEP RED SHADOW
Indian red, dioxazine mauve and indanthrene blue

Painting

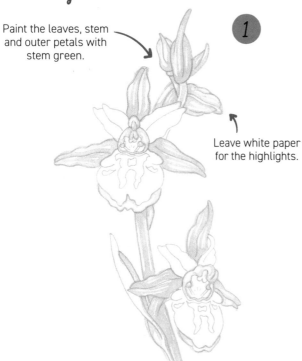

Paint the leaves, stem and outer petals with stem green.

1

Leave white paper for the highlights.

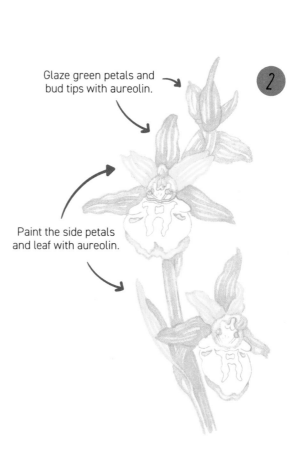

Glaze green petals and bud tips with aureolin.

2

Paint the side petals and leaf with aureolin.

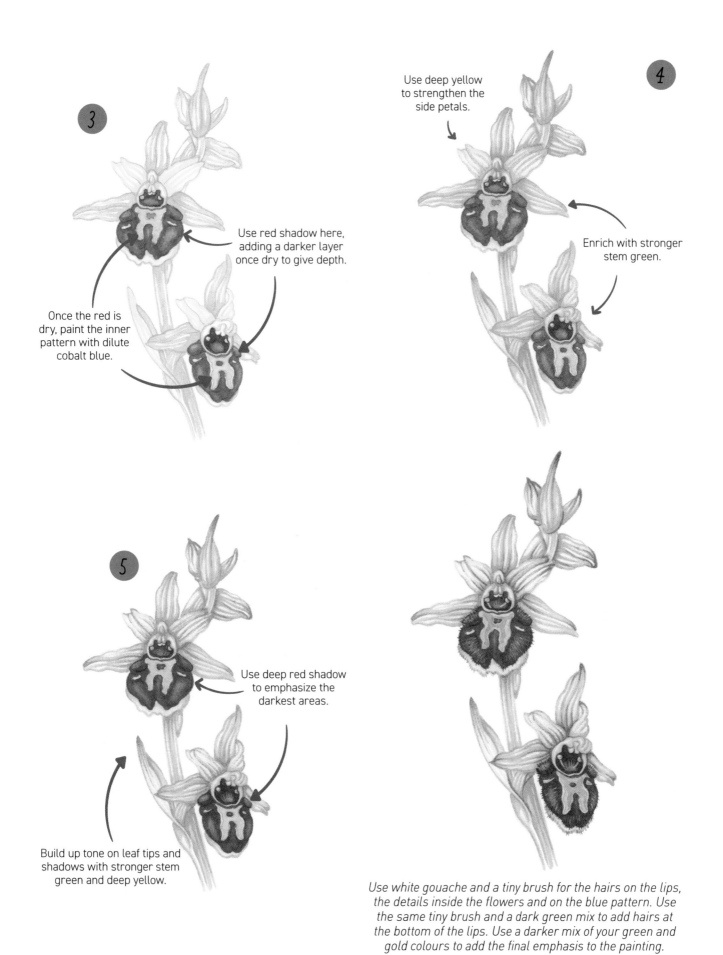

3

Use red shadow here, adding a darker layer once dry to give depth.

Once the red is dry, paint the inner pattern with dilute cobalt blue.

4

Use deep yellow to strengthen the side petals.

Enrich with stronger stem green.

5

Use deep red shadow to emphasize the darkest areas.

Build up tone on leaf tips and shadows with stronger stem green and deep yellow.

Use white gouache and a tiny brush for the hairs on the lips, the details inside the flowers and on the blue pattern. Use the same tiny brush and a dark green mix to add hairs at the bottom of the lips. Use a darker mix of your green and gold colours to add the final emphasis to the painting.

Sunflower

Drawing and colours

Do not worry if the flower centre looks a bit messy in the early stages. The detail you add later will correct that.

The watercolour paints you need for this flower are: aureolin, alizarin crimson, red gold lake, sap green, French ultramarine, yellow ochre, Indian red, van Dyck brown and Indian yellow-orange.

You will also need white gouache paint.

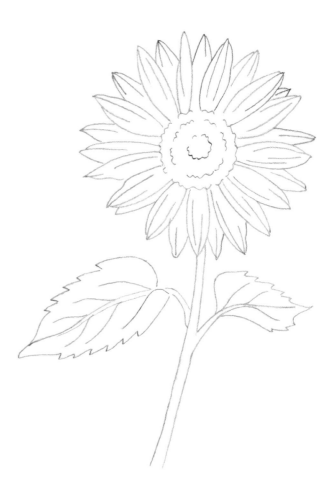

Mixed colours

 HOT ORANGE
Alizarin crimson and red gold lake

 STEM GREEN
Sap green and French ultramarine

 WARM SHADOW
Indian red and van Dyck brown

Painting

Use aureolin and a size 00 brush for the frontmost petals.

 1

Use linear brush strokes from base to tip, and leave white paper for highlights.

Once dry, paint the other petals. Leave fewer highlights where the petals overlap.

 2

Add more aureolin where petals overlap and to bases and tips.

Paint the flower centre aureolin.

3

Paint the shadows here using aureolin.

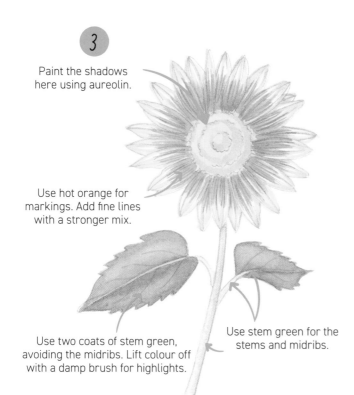

Use hot orange for markings. Add fine lines with a stronger mix.

Use two coats of stem green, avoiding the midribs. Lift colour off with a damp brush for highlights.

Use stem green for the stems and midribs.

Use mid-strength warm shadow to add texture.

Build up the texture more on the lower right-hand side to describe the shadow.

4

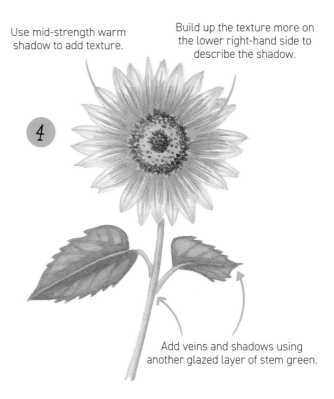

Add veins and shadows using another glazed layer of stem green.

Paint the shadows where the petals overlap with yellow ochre.

5

Using hot orange, strengthen the markings on the front petals only.

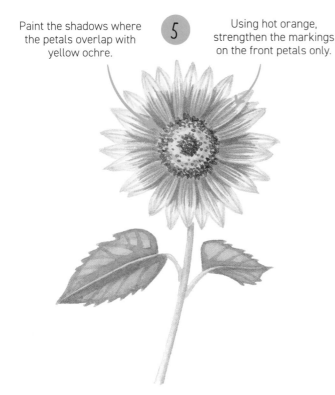

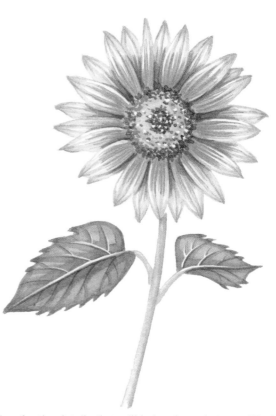

Now for the details that will bring the painting to life. Use Indian yellow-orange to strengthen the colour at the petal tips. Use warm shadow to draw thin lines between the petals. Add leaf veins with a stronger mix of stem green. Finally, use white gouache to add highlights to the petals and veins, and to the flower centre.

Waterlily

Drawing and colours

Start drawing the petals in the centre of the flower and work your way out, adding the outer petals.

The watercolour paints you need for this flower are: permanent rose, Indian red, sap green, golden green, aureolin, red gold lake, olive green and violet grey.

You will also need white gouache paint.

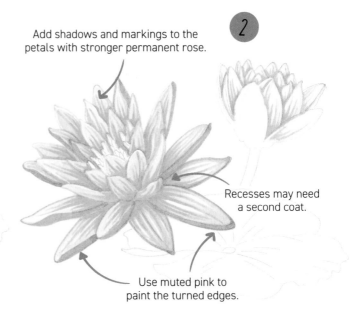

Mixed colours

 MUTED PINK
Permanent rose and Indian red

 SUNNY GREEN
Sap green and golden green

Painting

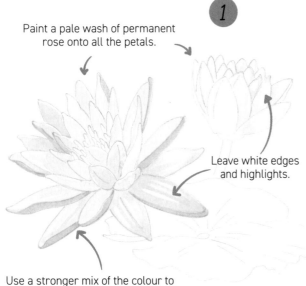

Paint a pale wash of permanent rose onto all the petals.

1

Leave white edges and highlights.

Use a stronger mix of the colour to paint the turned edges of the petals.

Add shadows and markings to the petals with stronger permanent rose.

2

Recesses may need a second coat.

Use muted pink to paint the turned edges.

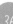

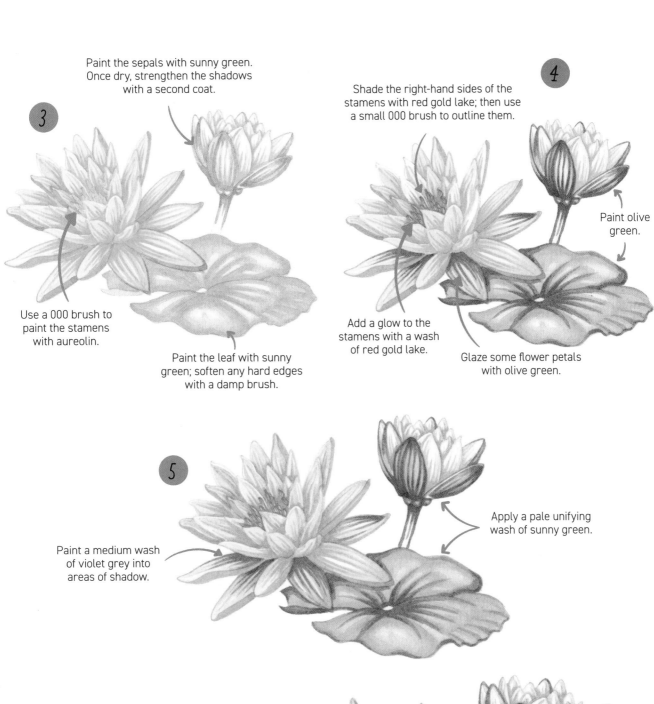

3

Paint the sepals with sunny green. Once dry, strengthen the shadows with a second coat.

Use a 000 brush to paint the stamens with aureolin.

Paint the leaf with sunny green; soften any hard edges with a damp brush.

4

Shade the right-hand sides of the stamens with red gold lake; then use a small 000 brush to outline them.

Paint olive green.

Add a glow to the stamens with a wash of red gold lake.

Glaze some flower petals with olive green.

5

Paint a medium wash of violet grey into areas of shadow.

Apply a pale unifying wash of sunny green.

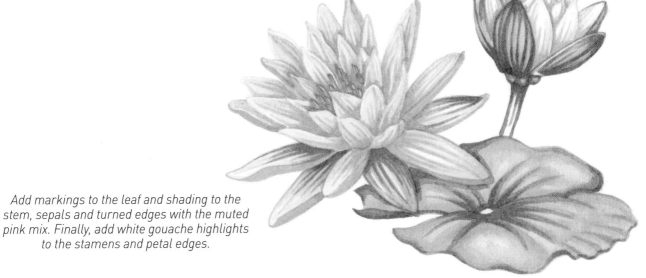

Add markings to the leaf and shading to the stem, sepals and turned edges with the muted pink mix. Finally, add white gouache highlights to the stamens and petal edges.

Witch Hazel

Drawing and colours

This is a complex drawing, so take care to draw all the curves and twists of the petals accurately.

The watercolour paints you need for this flower are: gamboge lake, chromium oxide, Indian red, sepia, red gold lake and indanthrene blue.

You will also need white gouache paint.

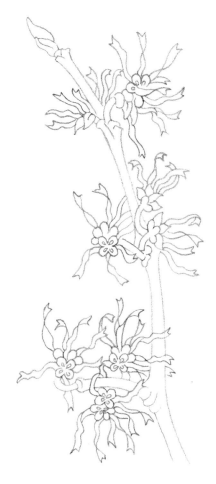

Mixed colours

DARK GREY
Strong Indian red and indanthrene blue

Painting

1

Use medium strength gamboge lake and a size 0 brush for the petals.

Leave streaks of white paper for highlights.

Add the tiny spots in the flower centres with gamboge lake, too.

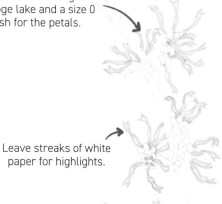

2

Use chromium oxide for the buds.

Use Indian red for the flower centres, leaving highlights.

These are very small, fiddly shapes to paint. Any wobbles can be corrected later.

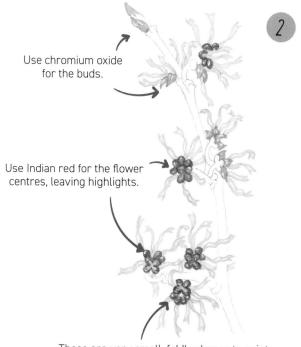

3

Use mid-strength sepia for the stems and flower bases.

Leave highlights to suggest the bark texture.

Once dry, glaze areas of shadow with paler sepia.

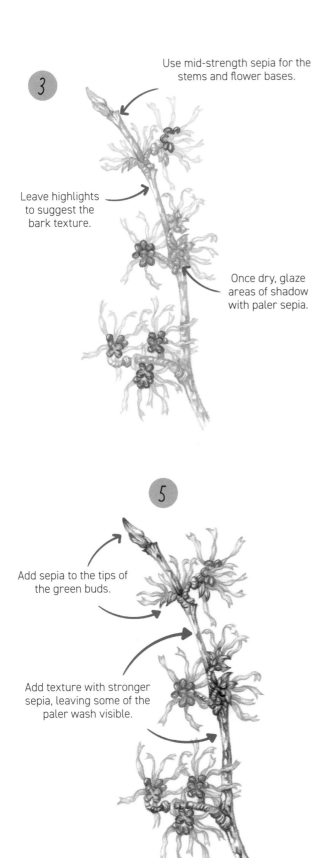

4

Use mid-strength red gold lake and a size 00 brush to add shape.

Concentrate on the petal tips, areas of shadow at the bases, and where they twist over.

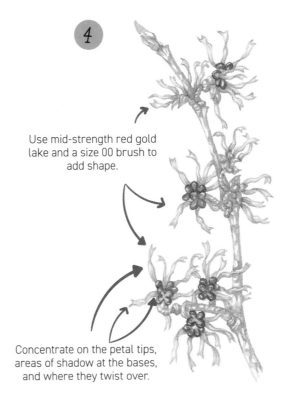

5

Add sepia to the tips of the green buds.

Add texture with stronger sepia, leaving some of the paler wash visible.

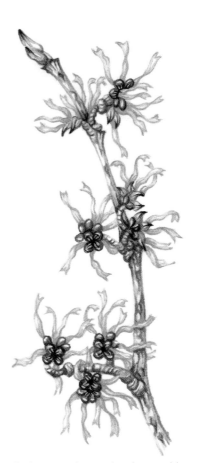

Use the dark grey mix to paint the markings in the flower centres and to darken the tips of the buds. Use white gouache to add highlights to the segments of the red flower centres.

Yellow Patio Rose

Drawing and colours

Marking in the midribs of the leaves helps to plot their angles and curves.

The watercolour paints you need for this flower are: aureolin, burnt sienna, sap green, French ultramarine, gamboge lake, Indian red, green earth, Indian yellow-orange and cadmium red light.

You will also need white gouache paint.

Mixed colours

SANDY YELLOW
Aureolin and burnt sienna

STEM SHADOW
Stronger sap green and French ultramarine

Painting

① Paint the petals with sandy yellow, blending in the highlights.

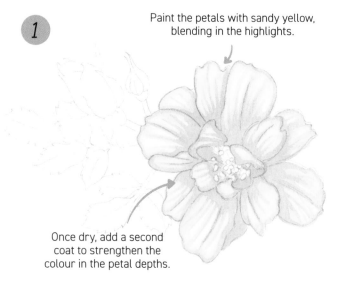

Once dry, add a second coat to strengthen the colour in the petal depths.

Paint the bud with two coats of aureolin, wet on dry.

②

Use Indian red to paint the stems.

Glaze the dark areas of the petals with gamboge lake.

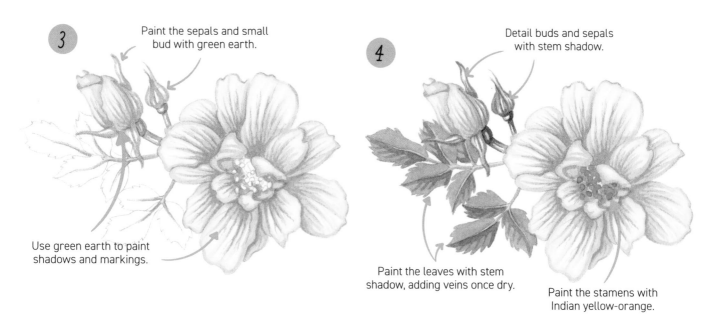

3 Paint the sepals and small bud with green earth.

Use green earth to paint shadows and markings.

4 Detail buds and sepals with stem shadow.

Paint the leaves with stem shadow, adding veins once dry.

Paint the stamens with Indian yellow-orange.

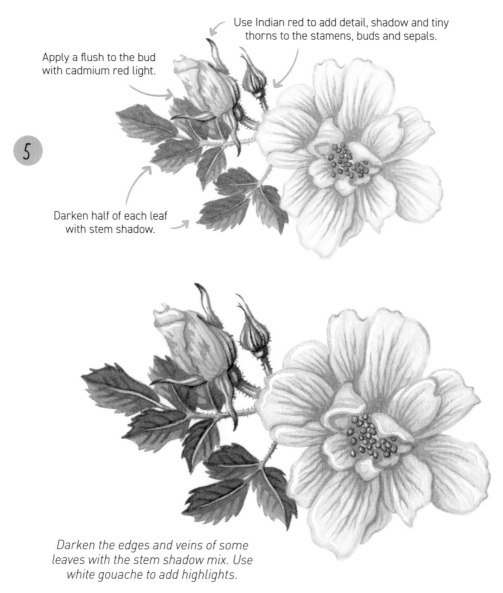

Use Indian red to add detail, shadow and tiny thorns to the stamens, buds and sepals.

Apply a flush to the bud with cadmium red light.

5

Darken half of each leaf with stem shadow.

Darken the edges and veins of some leaves with the stem shadow mix. Use white gouache to add highlights.

Arum Lily

Drawing and colours

Pay careful attention to the curves at the front edges of the petals – use faint guide lines to help you, and erase them afterwards. As this is a white flower, it's particularly important to lighten the pencil lines with a putty eraser before you start to paint.

The watercolour paints you need for this flower are: Payne's grey, aureolin, sap green, French ultramarine and Indian yellow-orange.

You will also need white gouache paint.

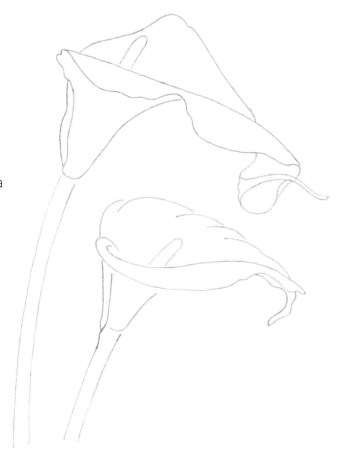

Mixed colours

STEM SHADOW
Stronger sap green and French ultramarine

Painting

1

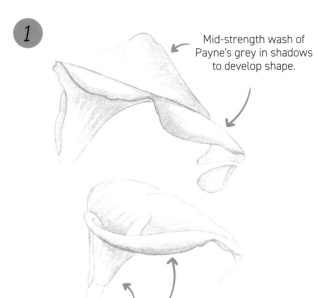

Mid-strength wash of Payne's grey in shadows to develop shape.

Soften any hard edges.

2

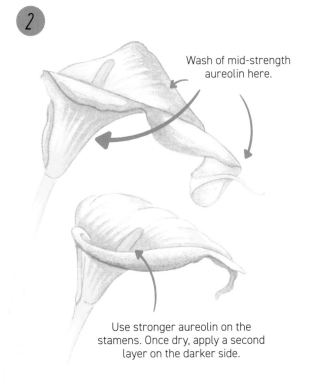

Wash of mid-strength aureolin here.

Use stronger aureolin on the stamens. Once dry, apply a second layer on the darker side.

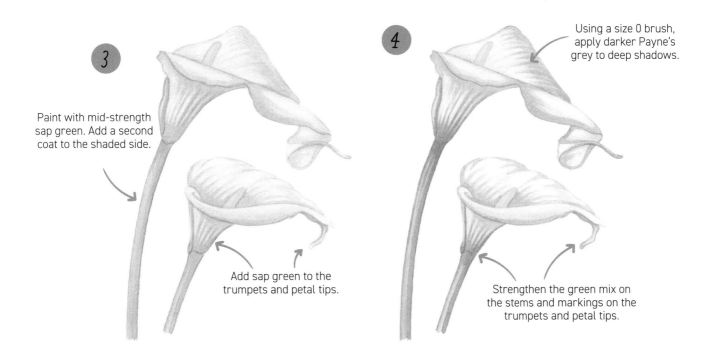

③ Paint with mid-strength sap green. Add a second coat to the shaded side.

Add sap green to the trumpets and petal tips.

④ Using a size 0 brush, apply darker Payne's grey to deep shadows.

Strengthen the green mix on the stems and markings on the trumpets and petal tips.

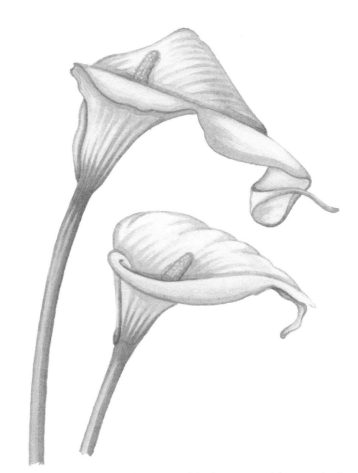

Continue strengthening the areas of darkest tone with stem shadow. If you need to refine the edges, add some French ultramarine to Payne's grey and apply the mix with a size 0 brush. Add textural markings to the stamens with the Indian yellow-orange then add highlights with white gouache to finish.

Canna Lily

Drawing and colours

Petals at the back of the flower spike need to be painted in less detail, so that they recede.

The watercolour paints you need for this flower are: cadmium red light, Indian red, alizarin crimson, gamboge lake, sap green, cobalt blue and indanthrene blue.

You will also need white gouache paint.

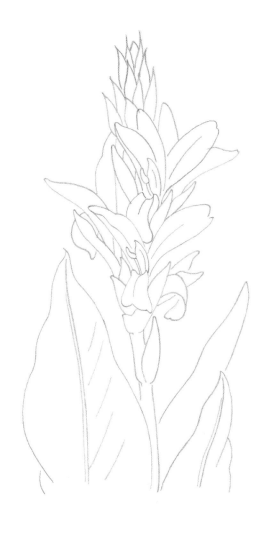

Mixed colours

 PLUM
Indian red and alizarin crimson

 COOL GREEN
Sap green and cobalt blue

 NEUTRAL GREY
Indian red and indanthrene blue

Painting

Use cadmium red light here, leaving white paper for highlights.

1

Add an overall wash to the petals at the back to make them recede.

Once dry, apply a second coat to areas of shadow.

Paint buds and sepals with the plum mix.

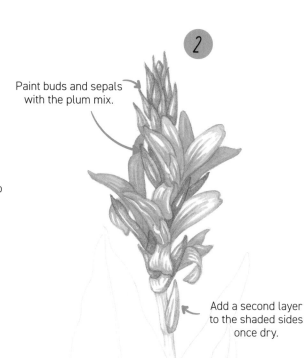

2

Add a second layer to the shaded sides once dry.

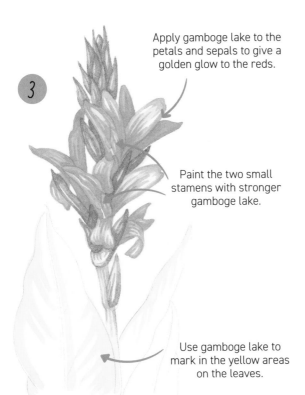

3

Apply gamboge lake to the petals and sepals to give a golden glow to the reds.

Paint the two small stamens with stronger gamboge lake.

Use gamboge lake to mark in the yellow areas on the leaves.

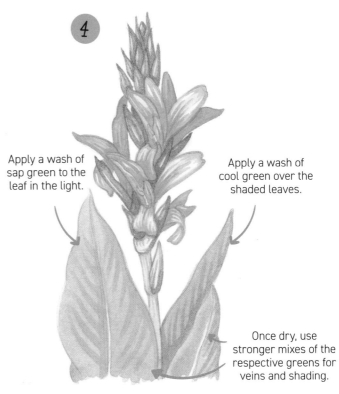

4

Apply a wash of sap green to the leaf in the light.

Apply a wash of cool green over the shaded leaves.

Once dry, use stronger mixes of the respective greens for veins and shading.

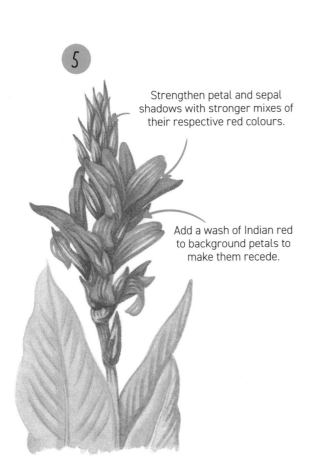

5

Strengthen petal and sepal shadows with stronger mixes of their respective red colours.

Add a wash of Indian red to background petals to make them recede.

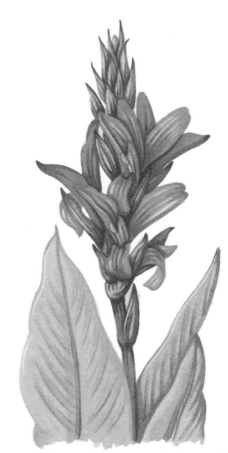

Use the neutral grey mix to deepen shadows and help the different elements stand out from each other. Use it to darken the tips of the petals and sepals, too. Add small touches of white gouache for the highlights and to delineate the stamens.

Slipper Orchid

Drawing and colours

Orchid flowers feature a bowl-like lower petal – work carefully here as the shapes are unusual. When painting step 5, you will need to drag the brush from side to side to create a wiggly line, tapering off as you reach the flower centre. Practise on spare paper first.

The watercolour paints you need for this flower are: aureolin, yellow ochre, sap green, carmine lake and quinacridone violet, Indian red, dioxazine mauve, cadmium red light and French ultramarine.

You will also need white gouache paint.

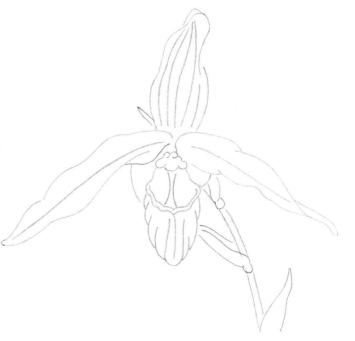

Mixed colours

 SUN YELLOW
Aureolin and yellow ochre

 SOFT PINK
Carmine lake and quinacridone violet

 PURPLE-GREY
Indian red and dioxazine mauve

 BOTANICAL GREY
Cadmium red light and French ultramarine

Painting

1

Use sun yellow to paint the central area.

Apply a second coat to darker areas once dry.

Add sap green to the base of the top petal.

Work from the centre of the petals outwards and soften the edges.

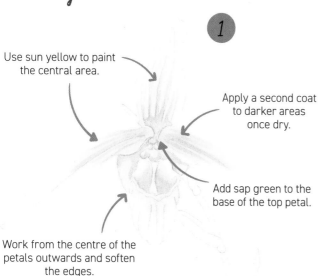

Use mid strength carmine lake here. Lift highlights and soften edges.

2

Leave the tips of the top and right-hand petals clean at this stage.

Once dry, build tone with a second wash of carmine lake in darker areas.

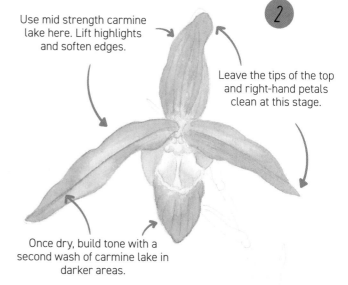

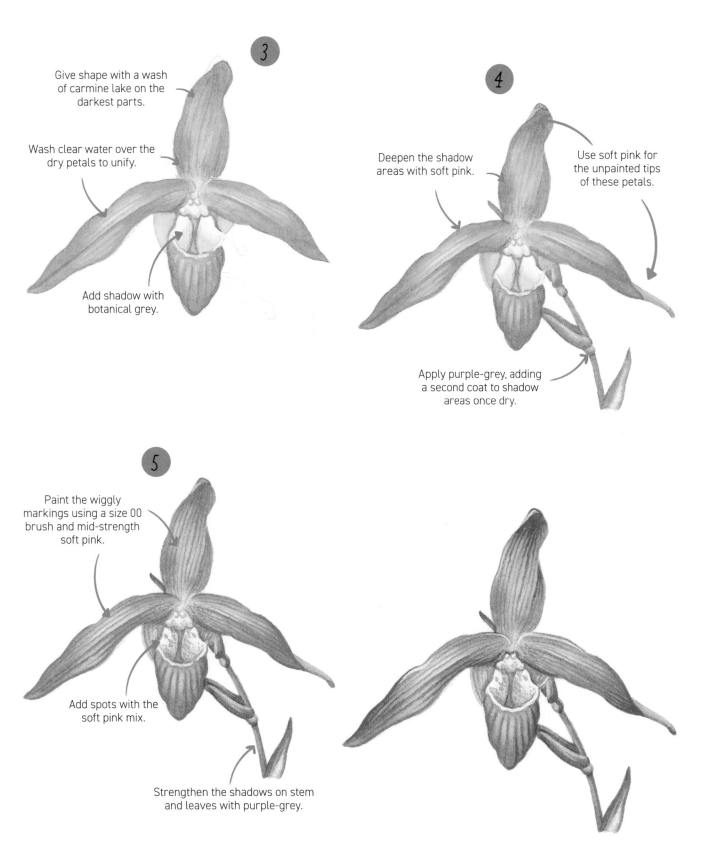

3

Give shape with a wash of carmine lake on the darkest parts.

Wash clear water over the dry petals to unify.

Add shadow with botanical grey.

4

Deepen the shadow areas with soft pink.

Use soft pink for the unpainted tips of these petals.

Apply purple-grey, adding a second coat to shadow areas once dry.

5

Paint the wiggly markings using a size 00 brush and mid-strength soft pink.

Add spots with the soft pink mix.

Strengthen the shadows on stem and leaves with purple-grey.

To finish, add some very dark touches of purple-grey or soft pink to the areas of deepest shadow and add bristles to the flower centre. Use white gouache to add a few highlights and neaten the edges.

Forget-me-not

Drawing and colours

When painting all these small petals, remember to let each one dry before painting the one next to it, to prevent the paint from bleeding.

The watercolour paints you need for this flower are: cyan, permanent rose, gamboge lake, sap green, Indian red and olive green.

You will also need white gouache paint.

Mixed colours

 WOODLAND GREEN
Sap green and cyan

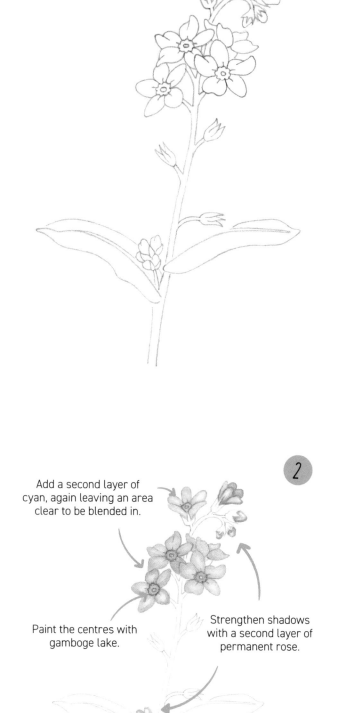

Painting

Mid-strength wash of cyan, leaving a white area in the centre of each petal.

Blend the paint into the white area with a damp brush.

Paint the buds with permanent rose.

1

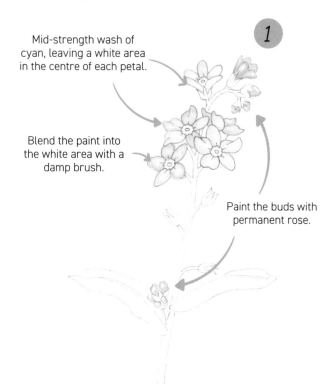

Add a second layer of cyan, again leaving an area clear to be blended in.

Paint the centres with gamboge lake.

Strengthen shadows with a second layer of permanent rose.

2

Use cyan to paint shadow lines onto the petals.

Paint the stems and sepals with sap green.

Use a pale wash of sap green, and blend into the highlights.

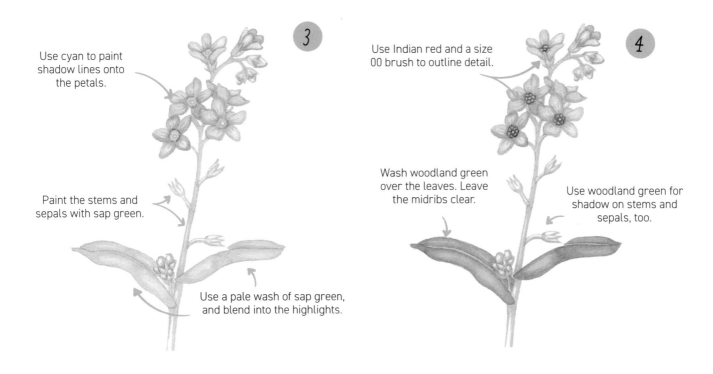

Use Indian red and a size 00 brush to outline detail.

Wash woodland green over the leaves. Leave the midribs clear.

Use woodland green for shadow on stems and sepals, too.

5

Glaze the three main flowers with cyan.

Add the markings with white gouache.

Add detail with olive green, concentrating on areas of shadow.

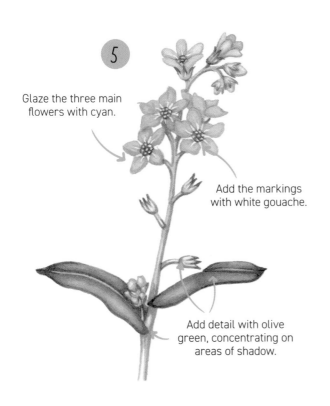

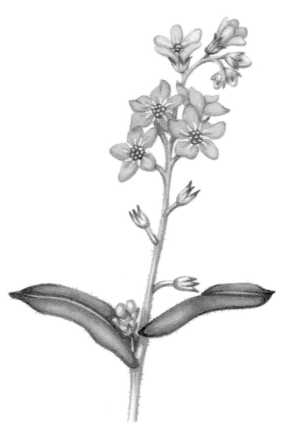

Darken the petal tips with cyan. Apply small touches of pale cyan to the shadow sides of the buds. Finally, use a sharp H pencil or a very small brush and olive green paint to draw tiny hairs on the stems and leaf edges. Keep the hairs uneven and don't draw too many.

Gorse

Drawing and colours

To capture the character of this plant, make sure that the large spines all curve downwards. Draw the curves of the small spines smoothly, and taper them towards the end to make them look sharp.

The watercolour paints you need for this flower are: cadmium lemon yellow, gamboge lake, golden green, chromium oxide, French ultramarine, sap green and burnt sienna.

Mixed colours

GREY-GREEN
Chromium oxide and French ultramarine

Painting

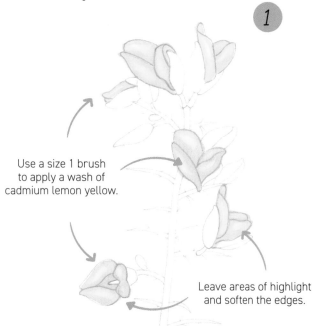

1

Use a size 1 brush to apply a wash of cadmium lemon yellow.

Leave areas of highlight and soften the edges.

2

Use gamboge lake and a size 0 brush to deepen the colour and add shading.

Paint golden green onto the sepals and buds in two layers, wet on dry.

3

Shade the bases of buds and sepals with sap green.

Paint the stems and spines with a pale mix of grey-green. Use a size 0 brush with a good point.

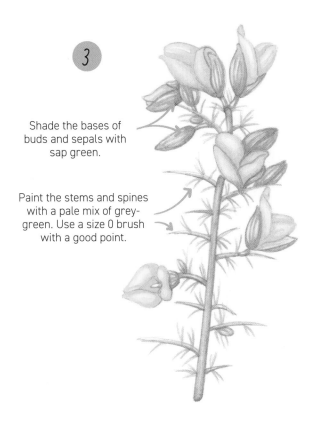

4

Shade the stems and spines with stronger grey-green.

Use the stronger grey-green for shadows at the base of sepals and buds.

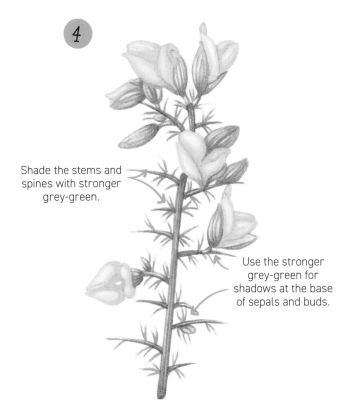

5

Add definition with burnt sienna.

Paint burnt sienna onto the tips of the buds, sepals and larger spines.

Add further dark grey-green mix to the lower edges of the spines.

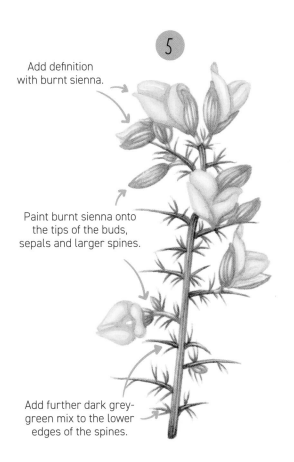

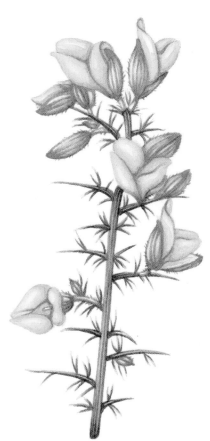

Use a 00 brush to paint tiny hairs on the sepals and buds with golden green, and also to add more definition to the darkest parts of the petals. Lastly, add a pale wash of cadmium lemon yellow to the stem and to any petals that need a stronger colour.

Marigold

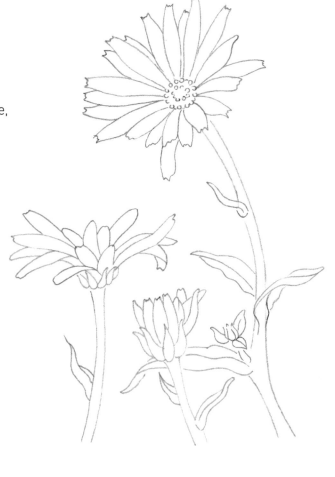

Drawing and colours

To achieve a painting that glows with summery sunshine, make sure the bright yellows and oranges of these marigold petals are kept clean.

The watercolour paints you need for this flower are: gamboge lake, red gold lake, Indian red, olive green, cadmium red deep, sap green, chromium oxide and French ultramarine.

You will also need white and yellow gouache paints.

Mixed colours

 RICH ORANGE
Red gold lake and cadmium red deep

 SOFT GREY
Sap green and chromium oxide

 STEM GREEN
Sap green and French ultramarine

Painting

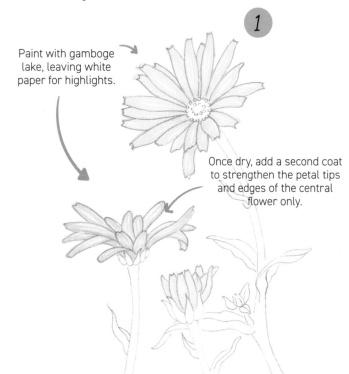

1

Paint with gamboge lake, leaving white paper for highlights.

Once dry, add a second coat to strengthen the petal tips and edges of the central flower only.

2

Use red gold lake and a size 0 brush to apply markings and shadow.

Start at the tips and taper off.

Once dry, apply a second coat to the petals of the top flower only.

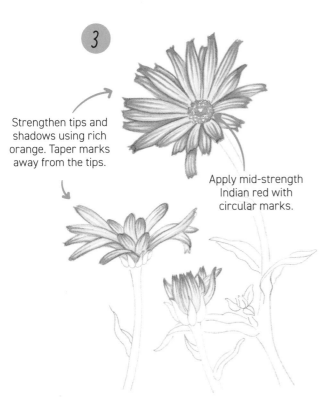

3

Strengthen tips and shadows using rich orange. Taper marks away from the tips.

Apply mid-strength Indian red with circular marks.

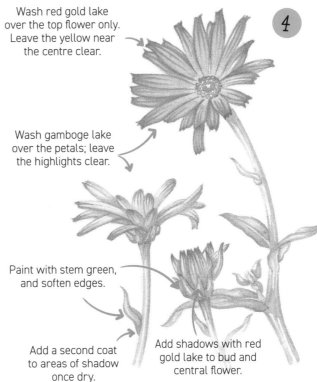

4

Wash red gold lake over the top flower only. Leave the yellow near the centre clear.

Wash gamboge lake over the petals; leave the highlights clear.

Paint with stem green, and soften edges.

Add a second coat to areas of shadow once dry.

Add shadows with red gold lake to bud and central flower.

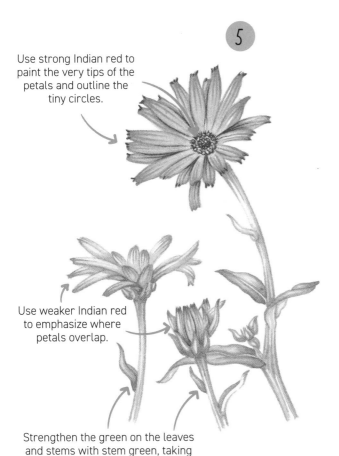

5

Use strong Indian red to paint the very tips of the petals and outline the tiny circles.

Use weaker Indian red to emphasize where petals overlap.

Strengthen the green on the leaves and stems with stem green, taking care not to cover the earlier work.

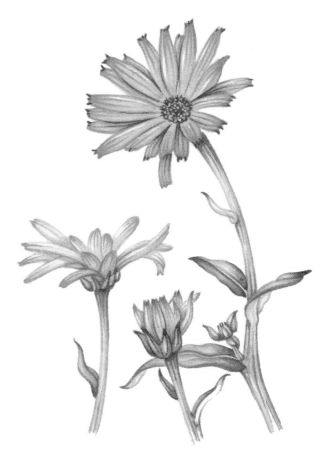

Use olive green on the darkest areas of the leaves and stems and add a few touches of pale gamboge lake to them to add a glow. Paint tiny dots of yellow gouache onto the flower centre. Use white gouache to add highlights to some of the petals of the top flower.

Red Passion Flower

Drawing and colours

Take care when drawing the serrations of the two large leaves, and mark their midribs.

The watercolour paints you need for this flower are: cadmium red light, yellow ochre, Indian yellow-orange, sap green, olive green, cadmium red deep, aureolin, dioxazine mauve and indanthrene blue.

You will also need white gouache paint.

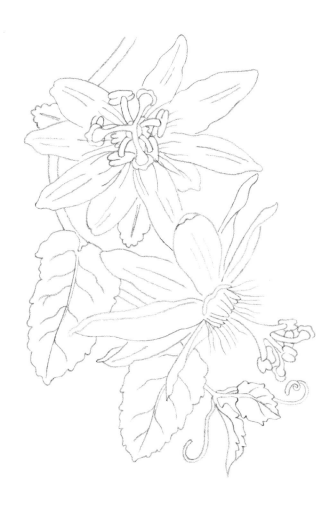

Mixed colours

 DEEP BLUE
Dioxazine mauve and indanthrene blue

Painting

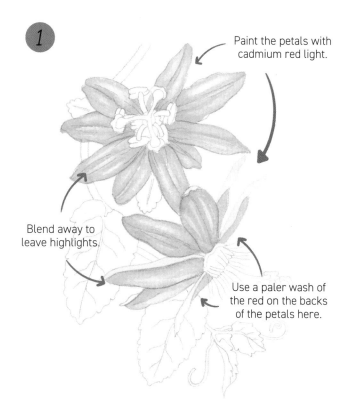

1

Paint the petals with cadmium red light.

Blend away to leave highlights.

Use a paler wash of the red on the backs of the petals here.

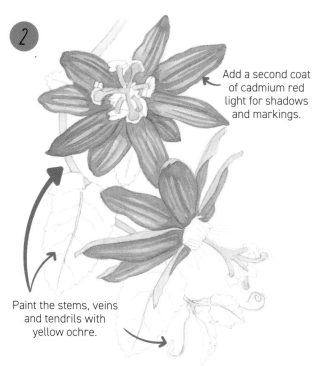

2

Add a second coat of cadmium red light for shadows and markings.

Paint the stems, veins and tendrils with yellow ochre.

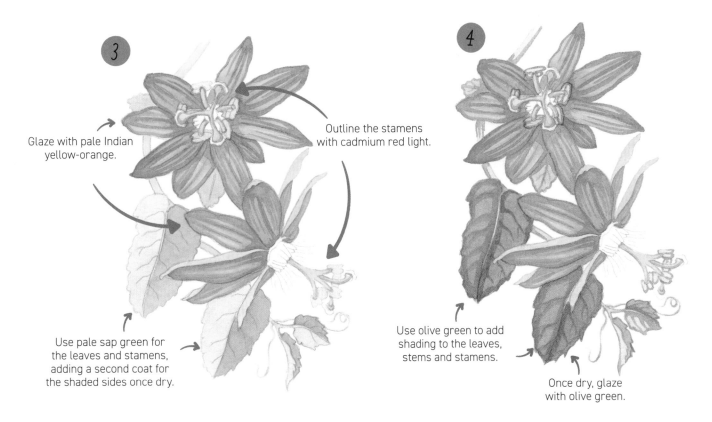

3

Glaze with pale Indian yellow-orange.

Outline the stamens with cadmium red light.

Use pale sap green for the leaves and stamens, adding a second coat for the shaded sides once dry.

4

Use olive green to add shading to the leaves, stems and stamens.

Once dry, glaze with olive green.

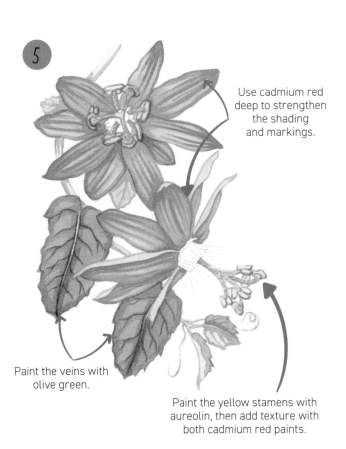

5

Use cadmium red deep to strengthen the shading and markings.

Paint the veins with olive green.

Paint the yellow stamens with aureolin, then add texture with both cadmium red paints.

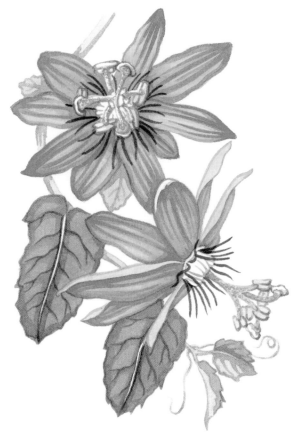

To finish, paint the frills at the flower centres with the deep blue mix, using a paler mix to line out the detail of the central flower structure. Use white gouache to add highlights to the midribs and stamens.

Peanut Cactus

Drawing and colours

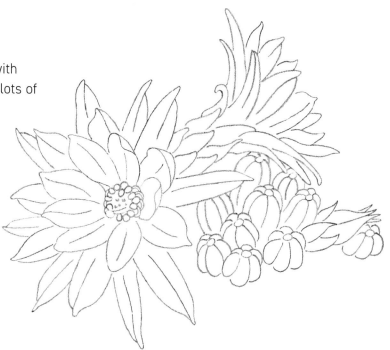

These showy orange flowers contrast well with the small peanut-like cacti. Take time to add lots of spines in the last stage.

The watercolour paints you need for this flower are: Naples yellow reddish, red gold lake, cadmium red light, green earth, olive green and gamboge lake.

You will also need white gouache paint.

Mixed colours

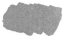

WARM ORANGE
Red gold lake and cadmium red light

Painting

1

Paint with Naples yellow reddish, leaving highlights and blending edges.

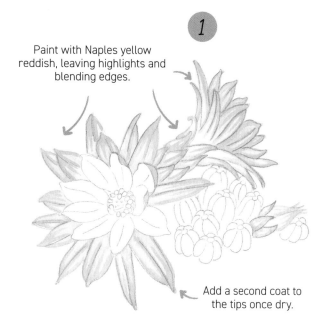

Add a second coat to the tips once dry.

2

Glaze some of the petals with red gold lake.

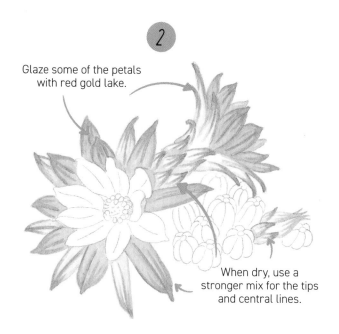

When dry, use a stronger mix for the tips and central lines.

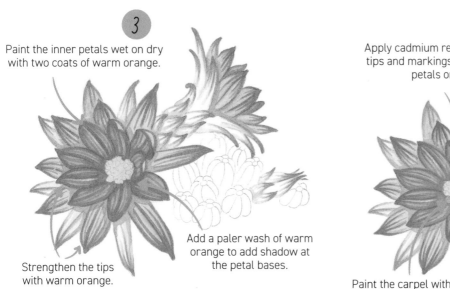

3

Paint the inner petals wet on dry with two coats of warm orange.

Strengthen the tips with warm orange.

Add a paler wash of warm orange to add shadow at the petal bases.

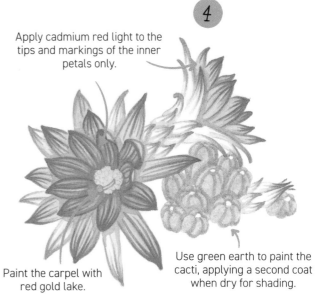

4

Apply cadmium red light to the tips and markings of the inner petals only.

Paint the carpel with red gold lake.

Use green earth to paint the cacti, applying a second coat when dry for shading.

5

Use olive green to develop the shadows of the cacti and at the base of the sepals.

Add detail to the cacti with a stronger mix of olive green.

Paint the stamens with gamboge lake and cadmium red light.

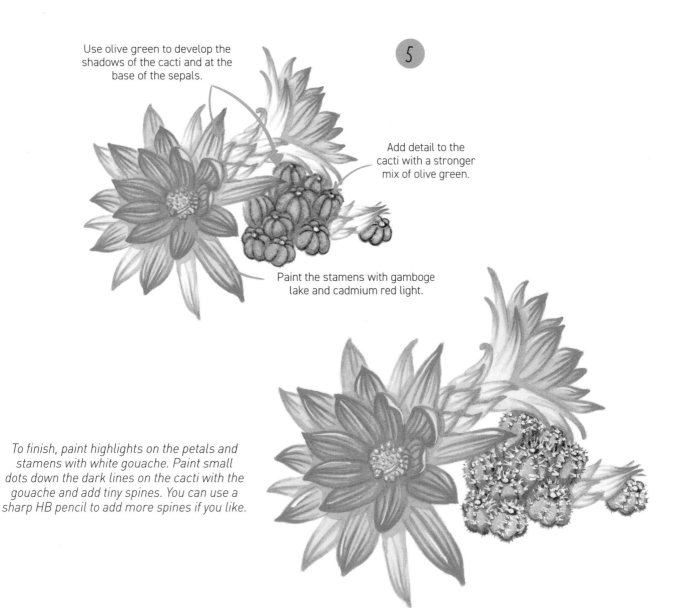

To finish, paint highlights on the petals and stamens with white gouache. Paint small dots down the dark lines on the cacti with the gouache and add tiny spines. You can use a sharp HB pencil to add more spines if you like.

Pink Orchid Tree

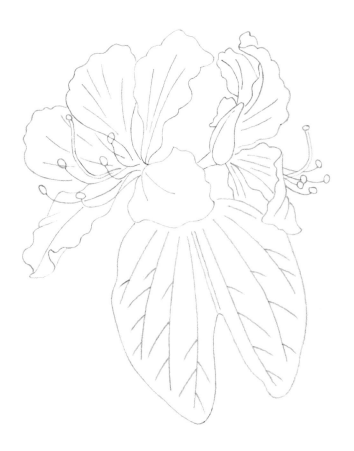

Drawing and colours

Use a brush with a fine point to paint the markings on the petals. The watercolour paints you need for this flower are: permanent rose, sap green, carmine lake, yellow ochre, Payne's grey, magenta, cobalt blue and sap green.

You will also need white gouache paint.

Mixed colours

 MAGENTA PINK
Magenta and carmine lake

 ROSE-BLUE
Permanent rose and cobalt blue

 COOL GREEN
Sap green and cobalt blue

Painting

1

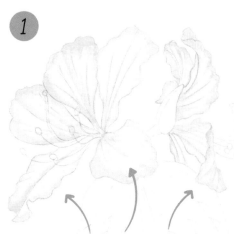

Paint the petals with permanent rose. Apply to the edges then add the markings, before blending with a damp brush.

Apply a second coat to strengthen the colour.

2

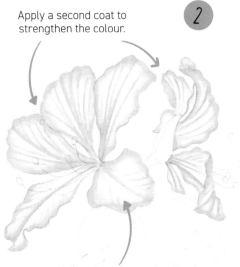

Take care not to cover all the work earlier – leave the highlights showing.

3

Use magenta pink here, tapering the brush strokes from the base to the edge.

Use the same mix for the top of the carpels.

Paint the sepal and carpels with sap green.

Use sap green here, leaving the highlights and veins clear.

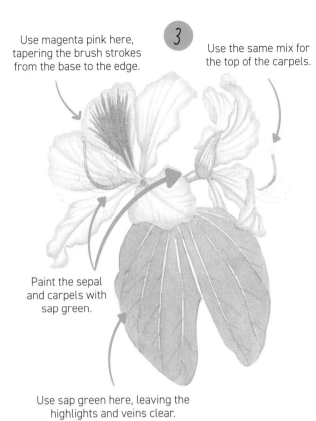

4

Use rose-blue to add shadows to the flowers.

Add shadows with cool green.

Paint leaf margin with cool green, then add shadows around the veins. Blend away edges.

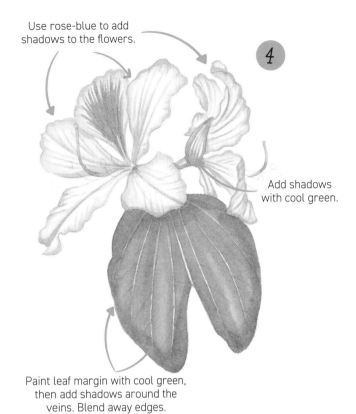

5

Glaze with a pale wash of permanent rose.

Use carmine lake here.

Leave the backs unglazed.

Paint the stamens and veins with yellow ochre.

Add shadows and veins with a stronger cool green mix once dry.

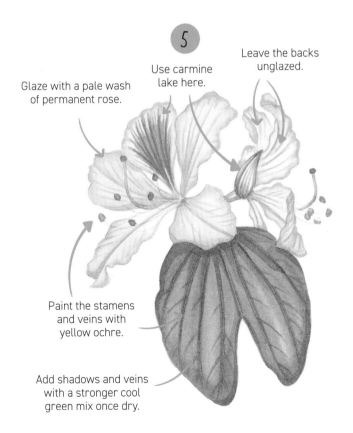

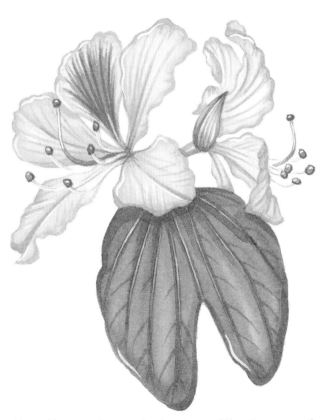

Use white gouache to paint the stems of the stamens and add Payne's grey for shadows. Paint white highlights on the leaf and flowers.

Rambling Rose

Drawing and colours

Add the veining in step 4 with a very fine brush, taking care to taper the lines away towards the petal edges.

The watercolour paints you need for this flower are: permanent rose, yellow ochre, carmine lake, sap green, French ultramarine and Indian red.

You will also need white gouache paint.

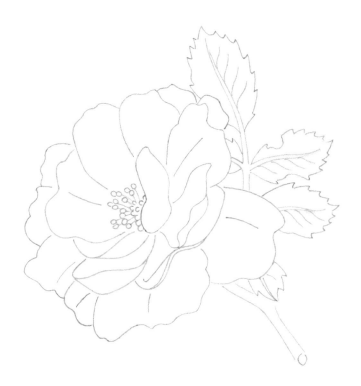

Mixed colours

STEM GREEN
Sap green and French ultramarine

Painting

1

Apply permanent rose, leaving highlights and blending edges.

Add the pink to the stems and midribs.

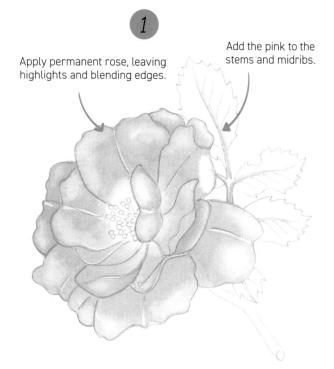

2

Add a second coat of permanent rose, concentrating on areas of shadow.

Glaze the stems with yellow ochre.

Add the stamens using yellow ochre.

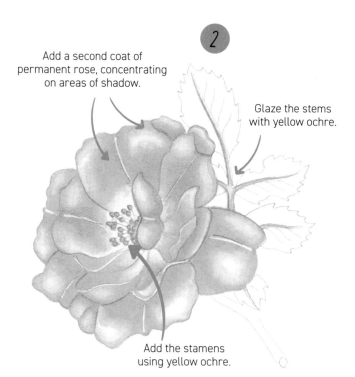

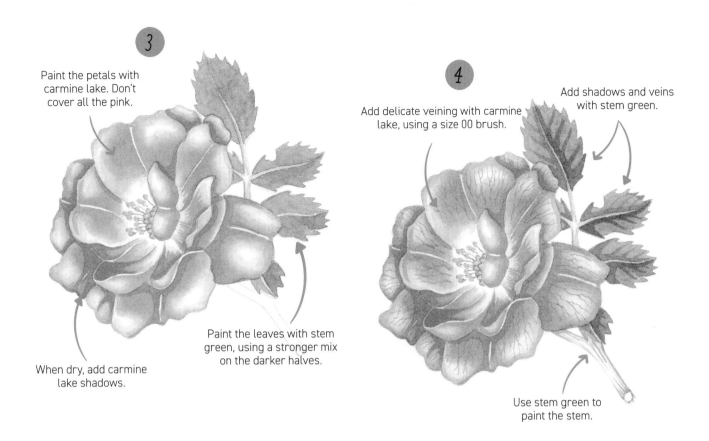

3

Paint the petals with carmine lake. Don't cover all the pink.

When dry, add carmine lake shadows.

Paint the leaves with stem green, using a stronger mix on the darker halves.

4

Add delicate veining with carmine lake, using a size 00 brush.

Add shadows and veins with stem green.

Use stem green to paint the stem.

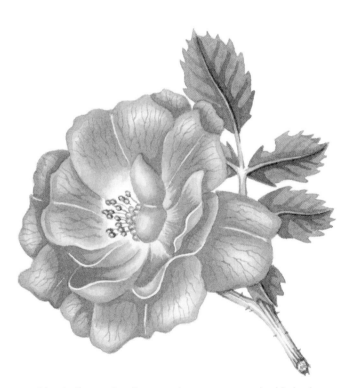

Use Indian red to line out the stamens and add shadow detail to the stems and midribs. Use white gouache to add highlights to the stamens and to neaten the edges of the lower petals.

Siam Tulip

Drawing and colours

This plant has decorative green and purple bracts on a long stem and tiny purple flowers that emerge from the bracts.

The watercolour paints you need for this flower are: sap green, yellow ochre, French ultramarine, magenta, dioxazine mauve and Indian red.

You will also need white gouache paint.

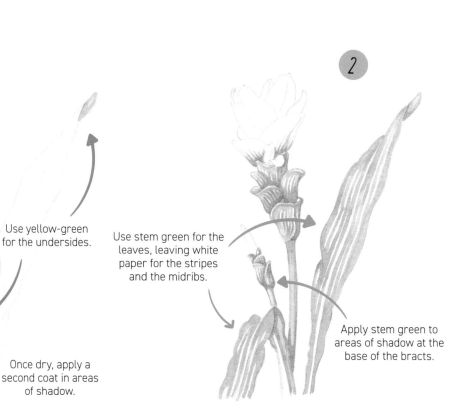

Mixed colours

YELLOW-GREEN
Sap green and yellow ochre

STEM GREEN
Sap green and French ultramarine

RED-MAGENTA
Magenta and Indian red

BLUE-MAGENTA
Dioxazine mauve and magenta

Painting

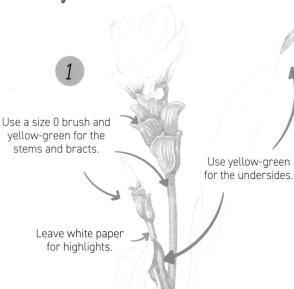

1

Use a size 0 brush and yellow-green for the stems and bracts.

Use yellow-green for the undersides.

Leave white paper for highlights.

Once dry, apply a second coat in areas of shadow.

2

Use stem green for the leaves, leaving white paper for the stripes and the midribs.

Apply stem green to areas of shadow at the base of the bracts.

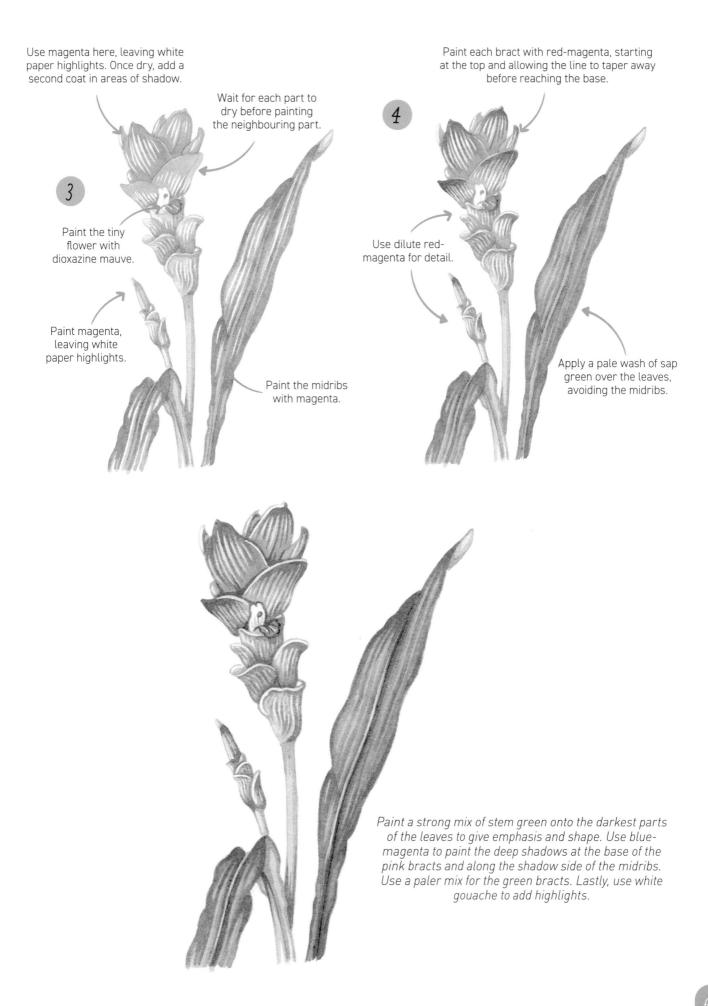

Use magenta here, leaving white paper highlights. Once dry, add a second coat in areas of shadow.

Wait for each part to dry before painting the neighbouring part.

Paint each bract with red-magenta, starting at the top and allowing the line to taper away before reaching the base.

3

Paint the tiny flower with dioxazine mauve.

Paint magenta, leaving white paper highlights.

Paint the midribs with magenta.

4

Use dilute red-magenta for detail.

Apply a pale wash of sap green over the leaves, avoiding the midribs.

Paint a strong mix of stem green onto the darkest parts of the leaves to give emphasis and shape. Use blue-magenta to paint the deep shadows at the base of the pink bracts and along the shadow side of the midribs. Use a paler mix for the green bracts. Lastly, use white gouache to add highlights.

Siberian Iris

Drawing and colours

To capture the shape of this iris, paint the petals at the back paler and with softer markings, so they recede.

The watercolour paints you need for this flower are: bright violet, dioxazine mauve, cadmium lemon yellow, sap green, Indian red, yellow ochre and French ultramarine.

You will also need white gouache paint.

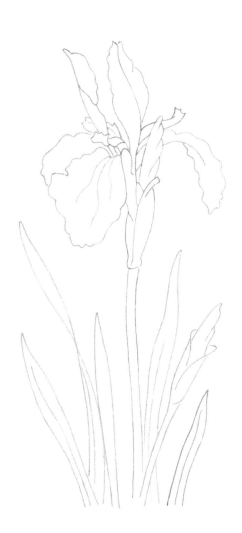

Mixed colours

 VIOLET-MAUVE
Bright violet and dioxazine mauve

 VIOLET-MAUVE SHADOW
Stronger mix of bright violet and dioxazine mauve

 STEM SHADOW
Stronger sap green and French ultramarine

Painting

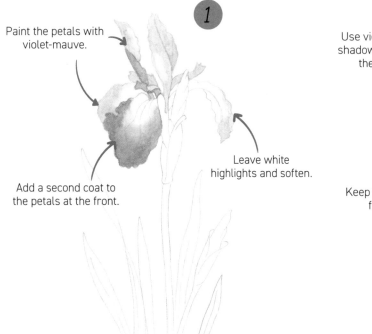

Paint the petals with violet-mauve.

Add a second coat to the petals at the front.

Leave white highlights and soften.

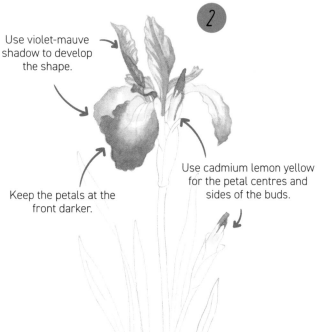

Use violet-mauve shadow to develop the shape.

Keep the petals at the front darker.

Use cadmium lemon yellow for the petal centres and sides of the buds.

3

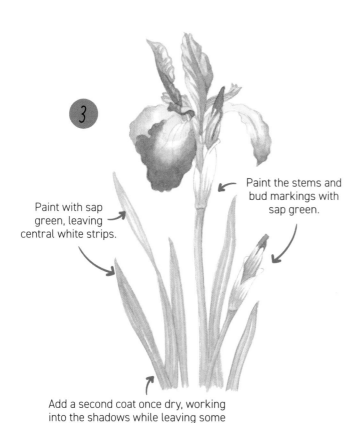

Paint with sap green, leaving central white strips.

Paint the stems and bud markings with sap green.

Add a second coat once dry, working into the shadows while leaving some of the first coat visible.

4

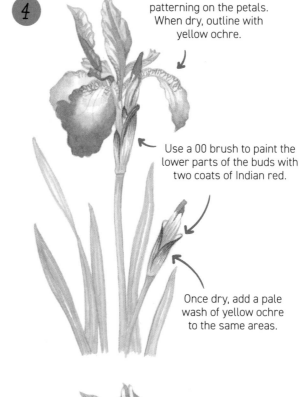

Use Indian red for the patterning on the petals. When dry, outline with yellow ochre.

Use a 00 brush to paint the lower parts of the buds with two coats of Indian red.

Once dry, add a pale wash of yellow ochre to the same areas.

5

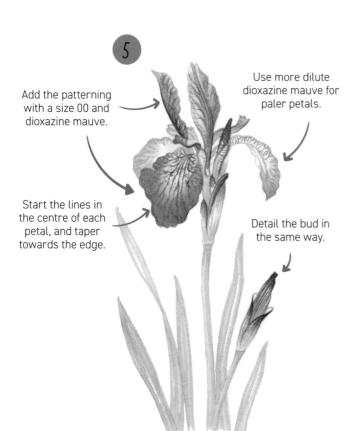

Add the patterning with a size 00 and dioxazine mauve.

Use more dilute dioxazine mauve for paler petals.

Start the lines in the centre of each petal, and taper towards the edge.

Detail the bud in the same way.

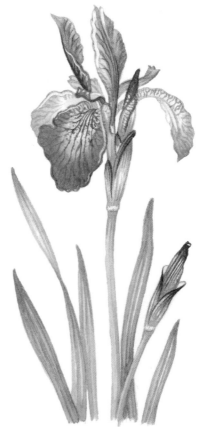

Use stem shadow to paint the textural lines on the leaves. Darken the shadows on the green parts of the buds. Wash a stroke of cadmium lemon yellow onto the leaves and stems to add glow. Lastly, use white gouache to add some highlights.

Yellow Skunk Cabbage

Drawing and colours

This plant has a central spike or spadix covered in tiny flowers, enclosed by the yellow leaf-like spathe. The leaves grow huge as the flowering stem dies back.

The watercolour paints you need for this flower are: aureolin, gamboge lake, sap green, cobalt blue and burnt sienna.

You will also need yellow and white gouache paints.

Mixed colours

COOL GREEN
Sap green and cobalt blue

Painting

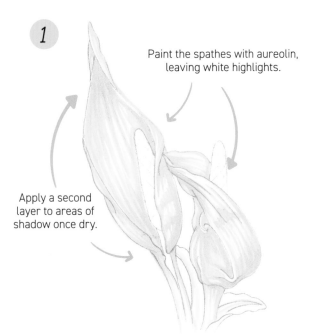

1

Paint the spathes with aureolin, leaving white highlights.

Apply a second layer to areas of shadow once dry.

2

Paint gamboge lake into the shadows – don't cover all the earlier painting.

Paint cool green onto the spadices and the undersides of the leaves.

Once dry, apply a second coat to give more depth.

3

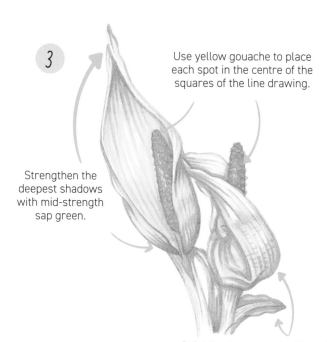

Use yellow gouache to place each spot in the centre of the squares of the line drawing.

Strengthen the deepest shadows with mid-strength sap green.

Paint the leaves, and add small vertical texture marks to the side of the smaller spathe, using sap green.

4

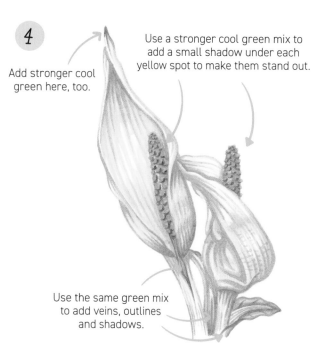

Add stronger cool green here, too.

Use a stronger cool green mix to add a small shadow under each yellow spot to make them stand out.

Use the same green mix to add veins, outlines and shadows.

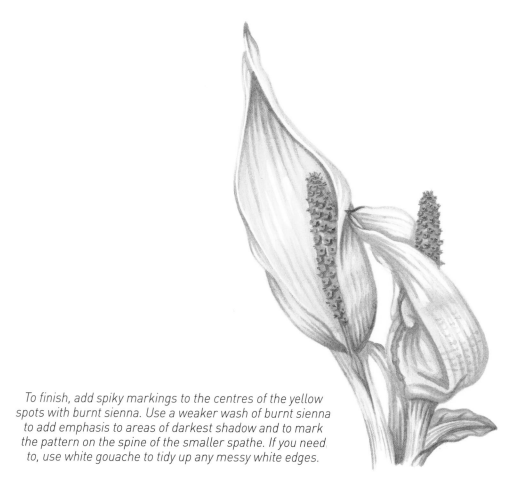

To finish, add spiky markings to the centres of the yellow spots with burnt sienna. Use a weaker wash of burnt sienna to add emphasis to areas of darkest shadow and to mark the pattern on the spine of the smaller spathe. If you need to, use white gouache to tidy up any messy white edges.

Cyclamen

Drawing and colours

Take care to draw the long curved stems as smoothly as you can.

The watercolour paints you need for this flower are: permanent rose, aureolin, sap green, bright violet, Indian red, chromium oxide, dioxazine mauve and Payne's grey. There are no mixed colours needed for this flower.

You will also need white gouache paint.

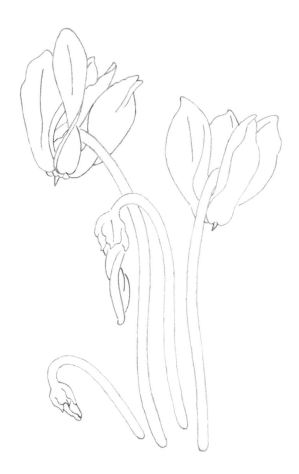

Painting

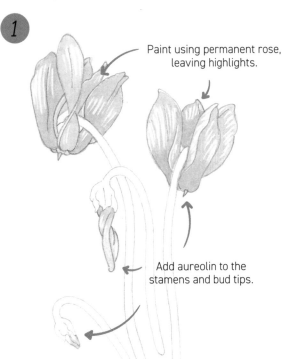

1

Paint using permanent rose, leaving highlights.

Add aureolin to the stamens and bud tips.

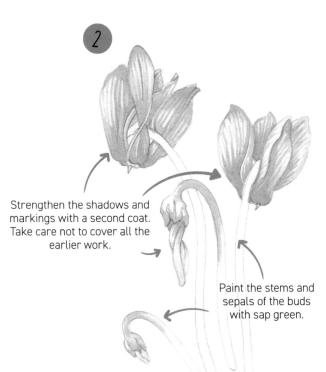

2

Strengthen the shadows and markings with a second coat. Take care not to cover all the earlier work.

Paint the stems and sepals of the buds with sap green.

③ Glaze with pale washes of bright violet. Let each section dry before painting the neighbouring section.

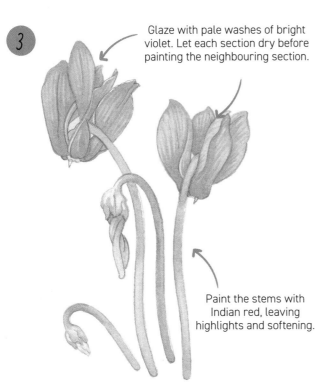

Paint the stems with Indian red, leaving highlights and softening.

④ Deepen the shading and markings with bright violet.

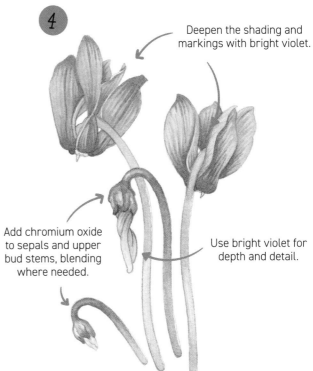

Add chromium oxide to sepals and upper bud stems, blending where needed.

Use bright violet for depth and detail.

⑤ Use mid-strength dioxazine mauve to deepen the darkest parts.

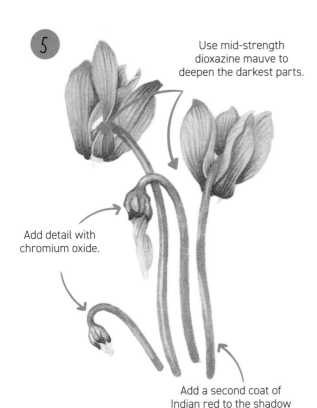

Add detail with chromium oxide.

Add a second coat of Indian red to the shadow sides of the stems.

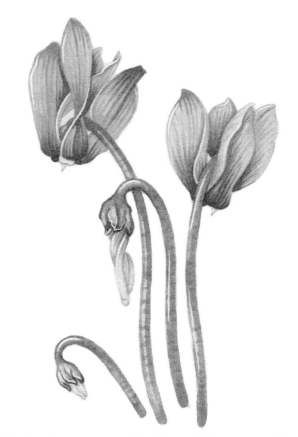

Outline the stamens and bud tips with Payne's grey, then add texture to the stems with Indian red. Take care not to make the marks too regular. For the finishing touches, add highlights with white gouache.

Mexican Sunflower

Drawing and colours

The simple daisy-like petals of this flower are set off by the more complex shapes of the leaves.

The watercolour paints you need for this flower are: gamboge lake, yellow ochre, Indian yellow-orange, sap green, French ultramarine, burnt sienna and chromium oxide.

You will also need white gouache paint.

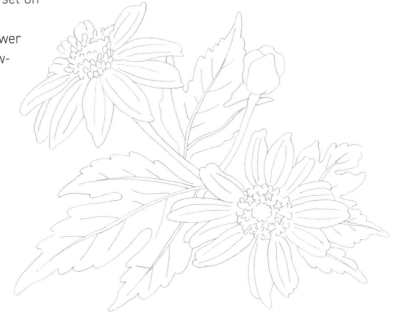

Mixed colours

STEM GREEN
Sap green and French ultramarine

Painting

1

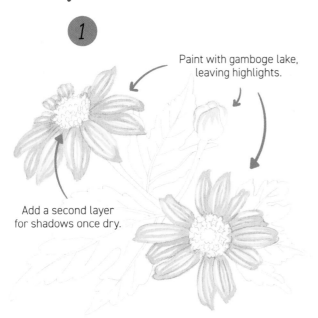

Paint with gamboge lake, leaving highlights.

Add a second layer for shadows once dry.

2

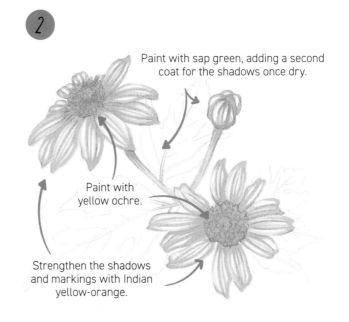

Paint with sap green, adding a second coat for the shadows once dry.

Paint with yellow ochre.

Strengthen the shadows and markings with Indian yellow-orange.

3

Use stem green to add shadows.

Paint with stem green, leaving highlights and blending. Start at the bases and work towards the edges. Leave the midribs clear.

Take care painting around the petals. Use a size 0 brush with a good point.

4

Use strong gamboge lake to deepen the shadows and the tips.

Outline the small circles and stars in the centres with Indian yellow-orange.

Use stem green to add shadows and veins.

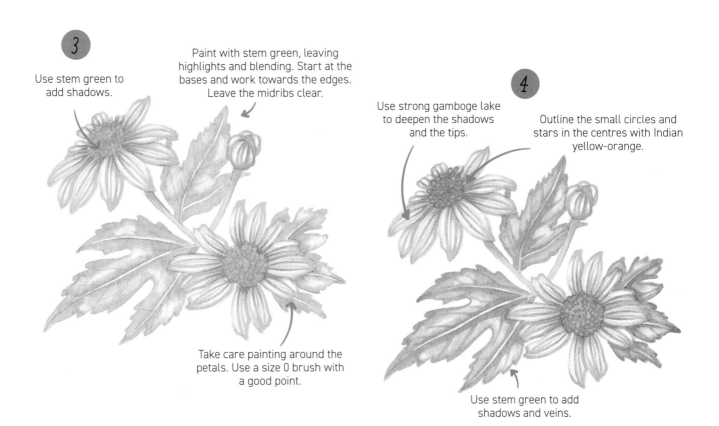

5

Outline the shadow side of the centre details with burnt sienna.

Add detail to the bud and leaf veins with chromium oxide.

To finish, add highlights to the flower centres, leaf veins and petals with white gouache, using a size 00 brush.

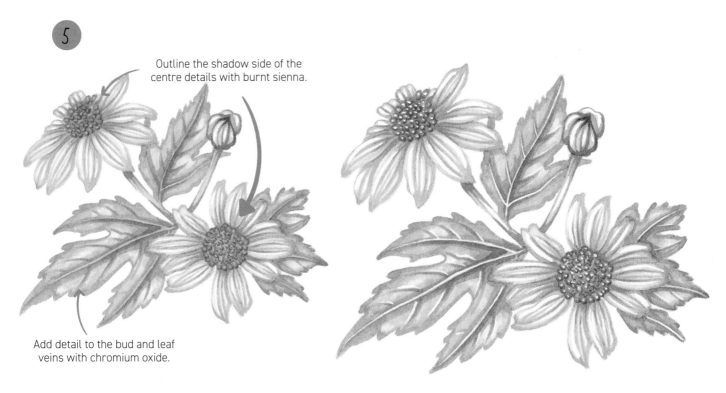

Water Hyacinth

Drawing and colours

This is a free-floating aquatic plant and, although very pretty, it is regarded as one of the world's most invasive weeds.

The watercolour paints you need for this flower are: gamboge lake, dioxazine mauve, sap green, cobalt blue, cyan, olive green and Payne's grey.

You will also need white gouache paint.

Mixed colours

 COOL GREEN
Sap green and cobalt blue

Painting

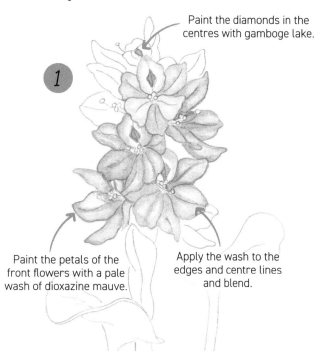

①

Paint the diamonds in the centres with gamboge lake.

Paint the petals of the front flowers with a pale wash of dioxazine mauve.

Apply the wash to the edges and centre lines and blend.

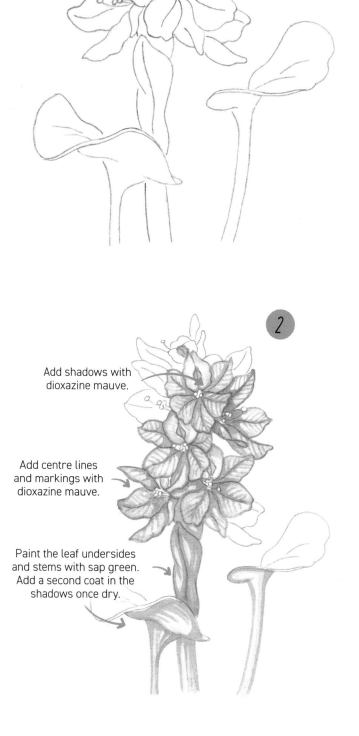

②

Add shadows with dioxazine mauve.

Add centre lines and markings with dioxazine mauve.

Paint the leaf undersides and stems with sap green. Add a second coat in the shadows once dry.

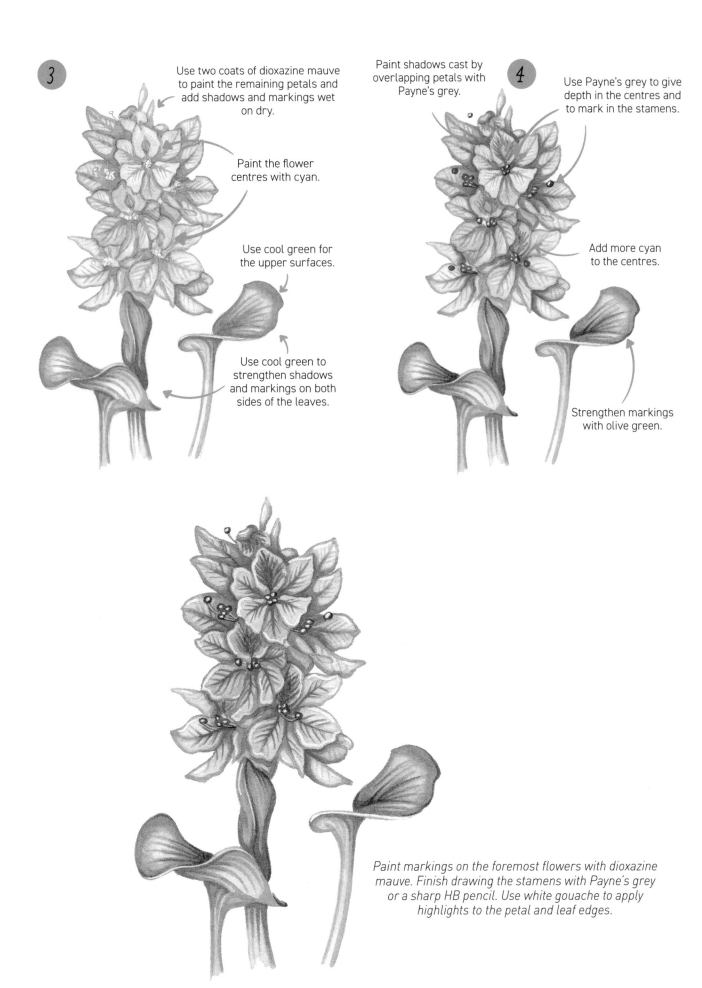

3 Use two coats of dioxazine mauve to paint the remaining petals and add shadows and markings wet on dry.

Paint the flower centres with cyan.

Use cool green for the upper surfaces.

Use cool green to strengthen shadows and markings on both sides of the leaves.

Paint shadows cast by overlapping petals with Payne's grey.

4 Use Payne's grey to give depth in the centres and to mark in the stamens.

Add more cyan to the centres.

Strengthen markings with olive green.

Paint markings on the foremost flowers with dioxazine mauve. Finish drawing the stamens with Payne's grey or a sharp HB pencil. Use white gouache to apply highlights to the petal and leaf edges.

73

Geum

Drawing and colours

Start by drawing the stems and the flower centres, and then add the petals.

The watercolour paints you need for this flower are: red gold lake, cadmium red light, Indian yellow-orange, burnt sienna, sap green and French ultramarine.

You will also need white and yellow gouache paints.

Mixed colours

 STEM GREEN
Sap green and French ultramarine

Painting

1

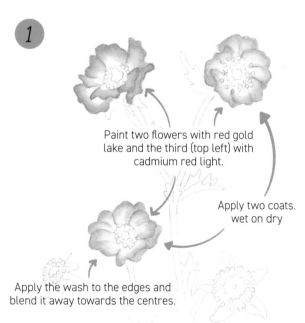

Paint two flowers with red gold lake and the third (top left) with cadmium red light.

Apply two coats. wet on dry

Apply the wash to the edges and blend it away towards the centres.

2

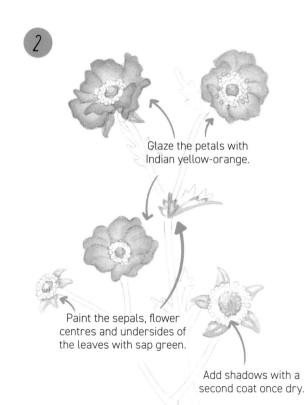

Glaze the petals with Indian yellow-orange.

Paint the sepals, flower centres and undersides of the leaves with sap green.

Add shadows with a second coat once dry.

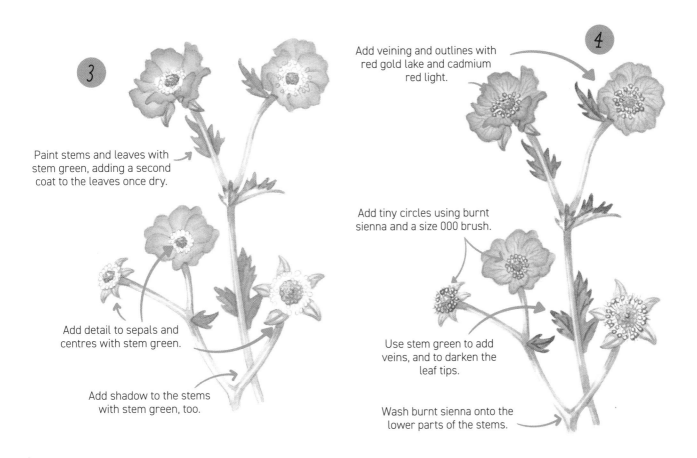

3

Paint stems and leaves with stem green, adding a second coat to the leaves once dry.

Add detail to sepals and centres with stem green.

Add shadow to the stems with stem green, too.

4

Add veining and outlines with red gold lake and cadmium red light.

Add tiny circles using burnt sienna and a size 000 brush.

Use stem green to add veins, and to darken the leaf tips.

Wash burnt sienna onto the lower parts of the stems.

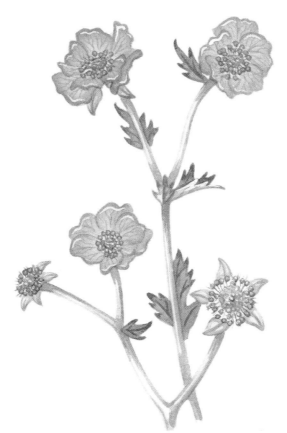

To finish, paint highlights onto the petals with white gouache and use yellow gouache to fill in the stamens.

Lobster Claws

Drawing and colours

These plants have tall flowering stems. The red claw shapes are bracts and the small flowers emerge from these bracts.

The watercolour paints you need for this flower are: red gold lake, cadmium red light, Indian yellow-orange, burnt sienna, sap green, French ultramarine, olive green and cobalt blue.

You will also need white and yellow gouache paints.

Mixed colours

EARTHY GREEN SHADOW
Olive green and cobalt blue

Painting

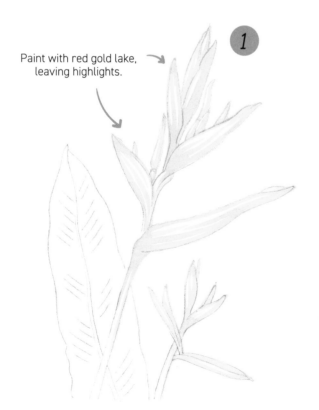

Paint with red gold lake, leaving highlights.

1

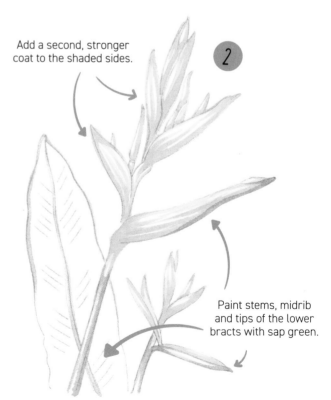

Add a second, stronger coat to the shaded sides.

2

Paint stems, midrib and tips of the lower bracts with sap green.

Strengthen the shadows on the bracts and flowers with Indian yellow-orange.

Paint the leaf with earthy green shadow.

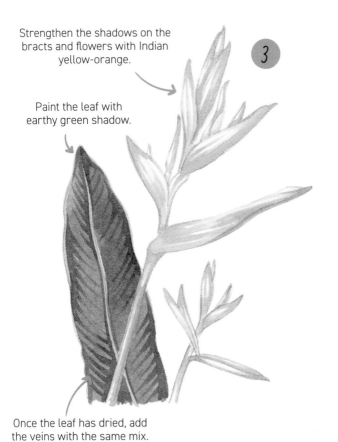

3

Once the leaf has dried, add the veins with the same mix.

4

Paint the red flush with cadmium red light.

Once dry, add a second coat to paint the parallel markings.

Mark veins out with cobalt blue.

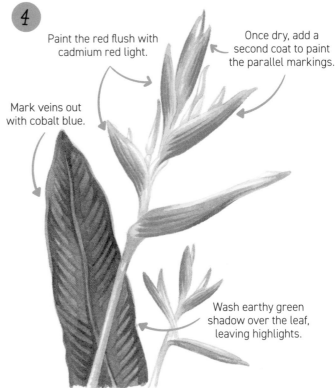

Wash earthy green shadow over the leaf, leaving highlights.

Use burnt sienna and a size 000 brush to make the edges crisp.

5

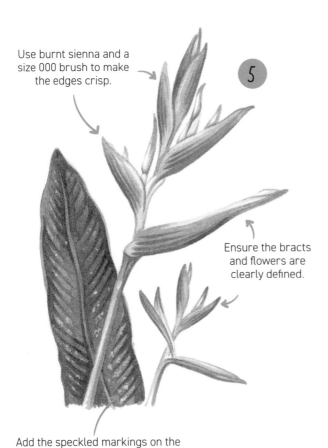

Ensure the bracts and flowers are clearly defined.

Add the speckled markings on the leaf with yellow gouache.

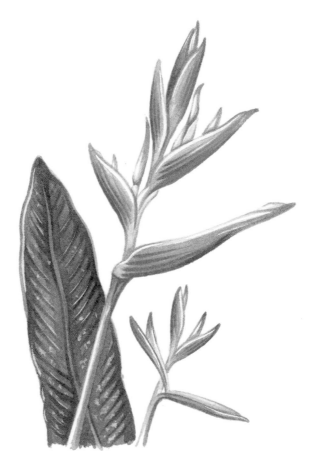

Use white gouache to pick out the highlights and define the edges.

Trumpet Vine

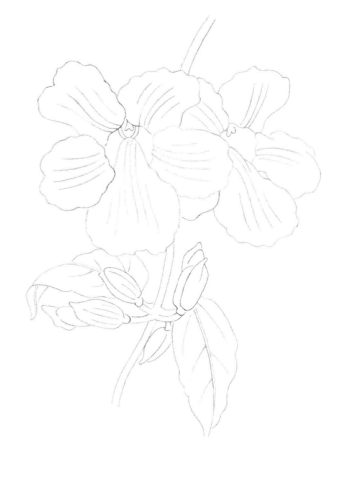

Drawing and colours

The violet markings on the petals help to define their shape, so take care to paint the curved lines smoothly.

The watercolour paints you need for this flower are: aureolin, violet grey, yellow ochre, sap green, cobalt blue, cadmium red light, French ultramarine, magenta, olive green and Indian red.

You will also need white gouache paint.

Mixed colours

 COOL GREEN
Sap green and cobalt blue

BOTANICAL GREY
Cadmium red light and French ultramarine

 COOL PINK
Violet grey and magenta

Painting

1 Paint with aureolin.

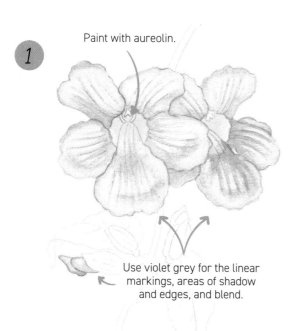

Use violet grey for the linear markings, areas of shadow and edges, and blend.

Add a second coat of violet grey to deepen the shadows and markings.

Use yellow ochre for the stems.

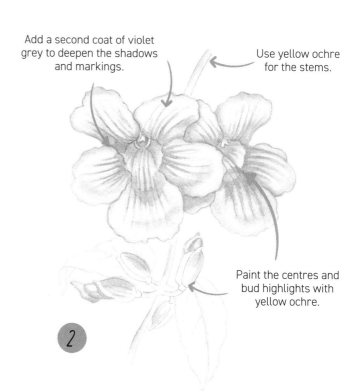

Paint the centres and bud highlights with yellow ochre.

2

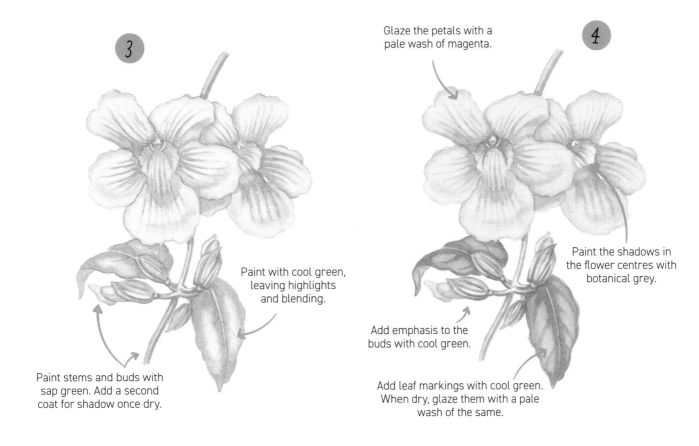

3

Glaze the petals with a
pale wash of magenta.

4

Paint with cool green,
leaving highlights
and blending.

Paint the shadows in
the flower centres with
botanical grey.

Add emphasis to the
buds with cool green.

Paint stems and buds with
sap green. Add a second
coat for shadow once dry.

Add leaf markings with cool green.
When dry, glaze them with a pale
wash of the same.

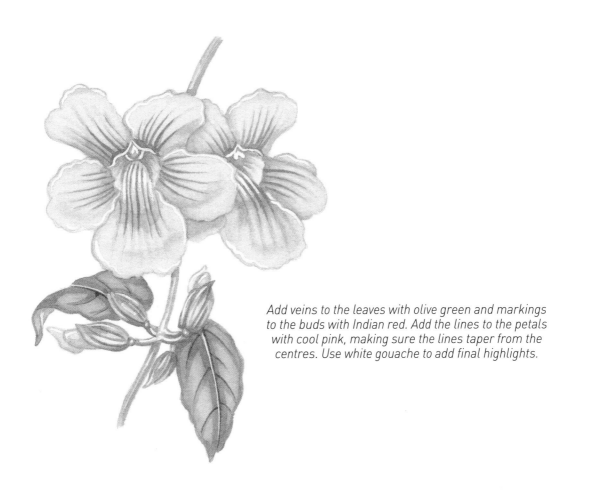

*Add veins to the leaves with olive green and markings
to the buds with Indian red. Add the lines to the petals
with cool pink, making sure the lines taper from the
centres. Use white gouache to add final highlights.*

Anemone

Drawing and colours

Draw the flower stem first, adding the stamens around the centre. Next, add the petals around this central area.

The watercolour paints you need for this flower are: bright violet, cobalt blue, aureolin, yellow ochre, Indian red, sap green, van Dyck brown and French ultramarine.

You will also need white gouache paint.

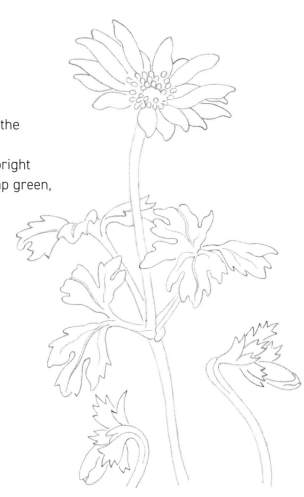

Mixed colours

 MUTED VIOLET
Bright violet and cobalt blue

 RED-GREY
Indian red and French ultramarine

 STEM GREEN
Sap green and French ultramarine

Painting

1

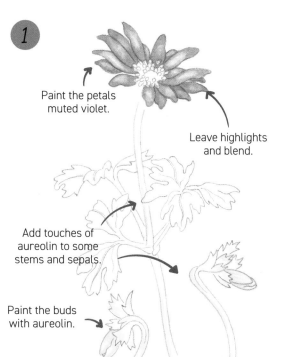

Paint the petals muted violet.

Leave highlights and blend.

Add touches of aureolin to some stems and sepals.

Paint the buds with aureolin.

2

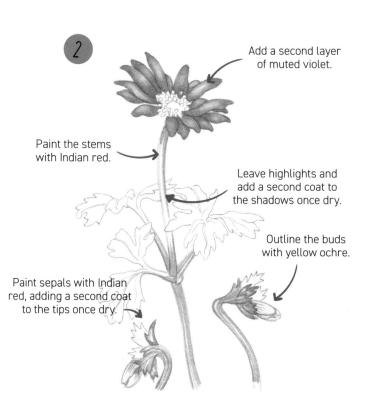

Add a second layer of muted violet.

Paint the stems with Indian red.

Leave highlights and add a second coat to the shadows once dry.

Outline the buds with yellow ochre.

Paint sepals with Indian red, adding a second coat to the tips once dry.

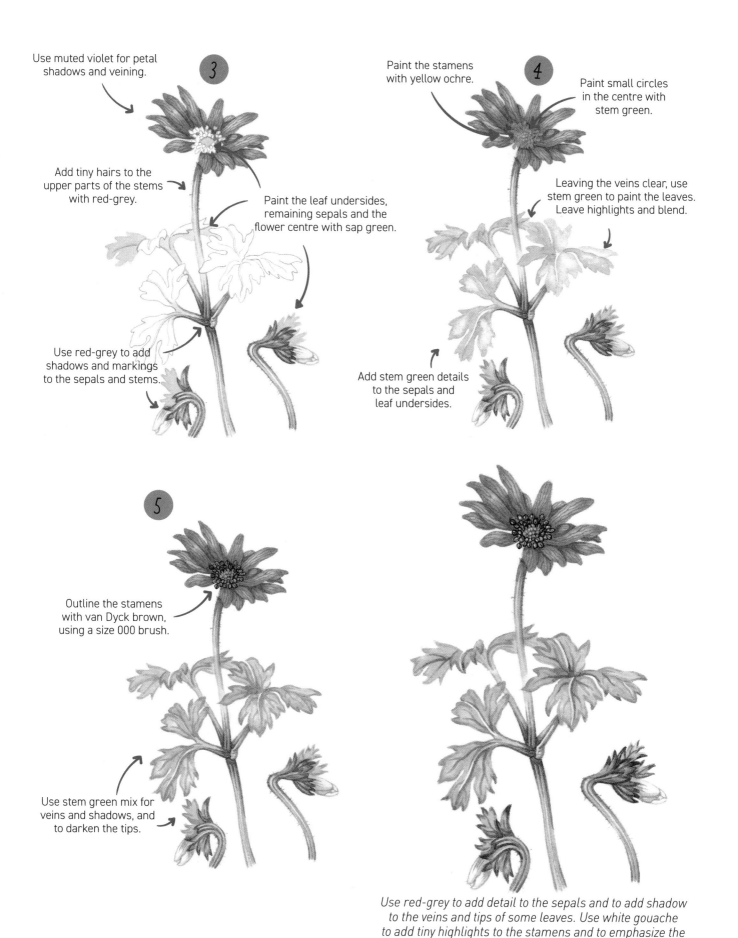

Use muted violet for petal shadows and veining.

3

Add tiny hairs to the upper parts of the stems with red-grey.

Paint the leaf undersides, remaining sepals and the flower centre with sap green.

Use red-grey to add shadows and markings to the sepals and stems.

Paint the stamens with yellow ochre.

4

Paint small circles in the centre with stem green.

Leaving the veins clear, use stem green to paint the leaves. Leave highlights and blend.

Add stem green details to the sepals and leaf undersides.

5

Outline the stamens with van Dyck brown, using a size 000 brush.

Use stem green mix for veins and shadows, and to darken the tips.

Use red-grey to add detail to the sepals and to add shadow to the veins and tips of some leaves. Use white gouache to add tiny highlights to the stamens and to emphasize the leaf veins.

Bird-of-paradise

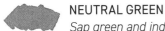

Drawing and colours

The colours of this dramatic plant are very individual. Capture them by layering the different shades and add glazes to make the colours glow.

The watercolour paints you need for this flower are: gamboge lake, violet grey, Indian yellow-orange, sap green, indanthrene blue, carmine lake and burnt sienna.

You will also need white gouache paint.

Mixed colours

NEUTRAL GREEN
Sap green and indanthrene blue

Painting

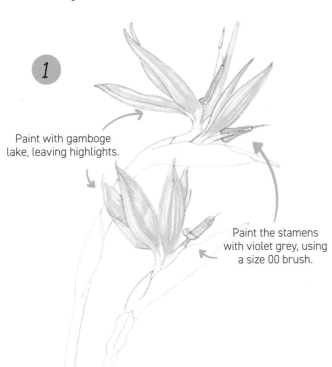

1

Paint with gamboge lake, leaving highlights.

Paint the stamens with violet grey, using a size 00 brush.

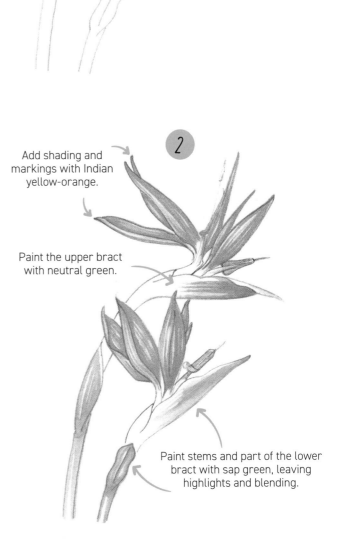

2

Add shading and markings with Indian yellow-orange.

Paint the upper bract with neutral green.

Paint stems and part of the lower bract with sap green, leaving highlights and blending.

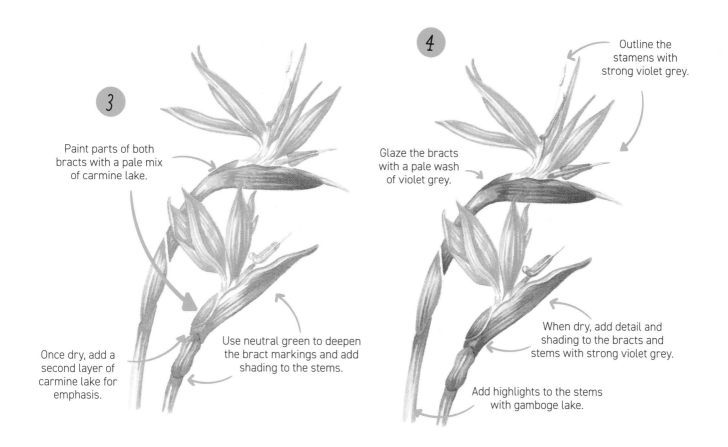

3

Paint parts of both bracts with a pale mix of carmine lake.

Use neutral green to deepen the bract markings and add shading to the stems.

Once dry, add a second layer of carmine lake for emphasis.

4

Outline the stamens with strong violet grey.

Glaze the bracts with a pale wash of violet grey.

When dry, add detail and shading to the bracts and stems with strong violet grey.

Add highlights to the stems with gamboge lake.

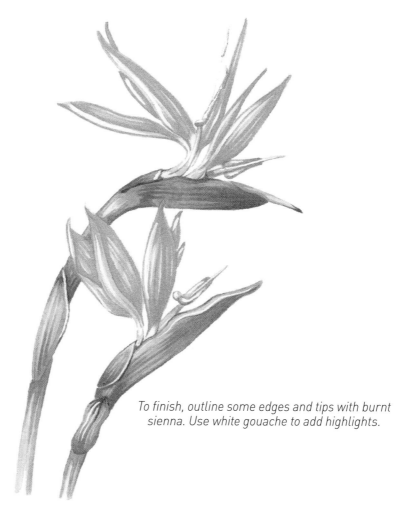

To finish, outline some edges and tips with burnt sienna. Use white gouache to add highlights.

Bird Orchid

Drawing and colours

Start with the main flower, then add the stems and side flower. Lastly, draw the buds and leaves.

The watercolour paints you need for this flower are: violet grey, aureolin, sap green, magenta and cobalt blue.

You will also need white gouache paint.

Mixed colours

 VIOLET-BLUE
Magenta and cobalt blue

 COOL GREEN
Sap green and cobalt blue

Painting

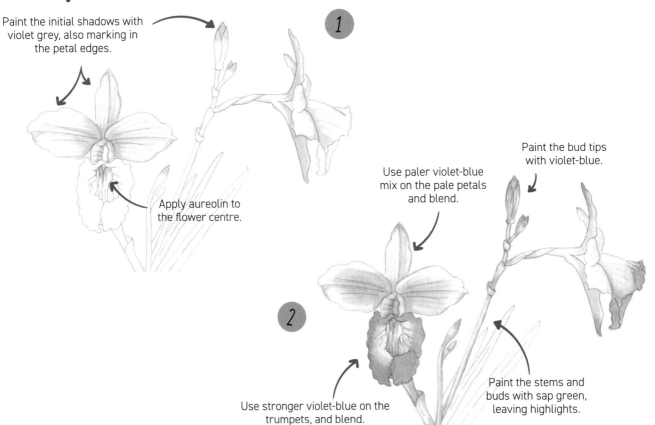

Paint the initial shadows with violet grey, also marking in the petal edges.

Apply aureolin to the flower centre.

1

Use paler violet-blue mix on the pale petals and blend.

Paint the bud tips with violet-blue.

2

Use stronger violet-blue on the trumpets, and blend.

Paint the stems and buds with sap green, leaving highlights.

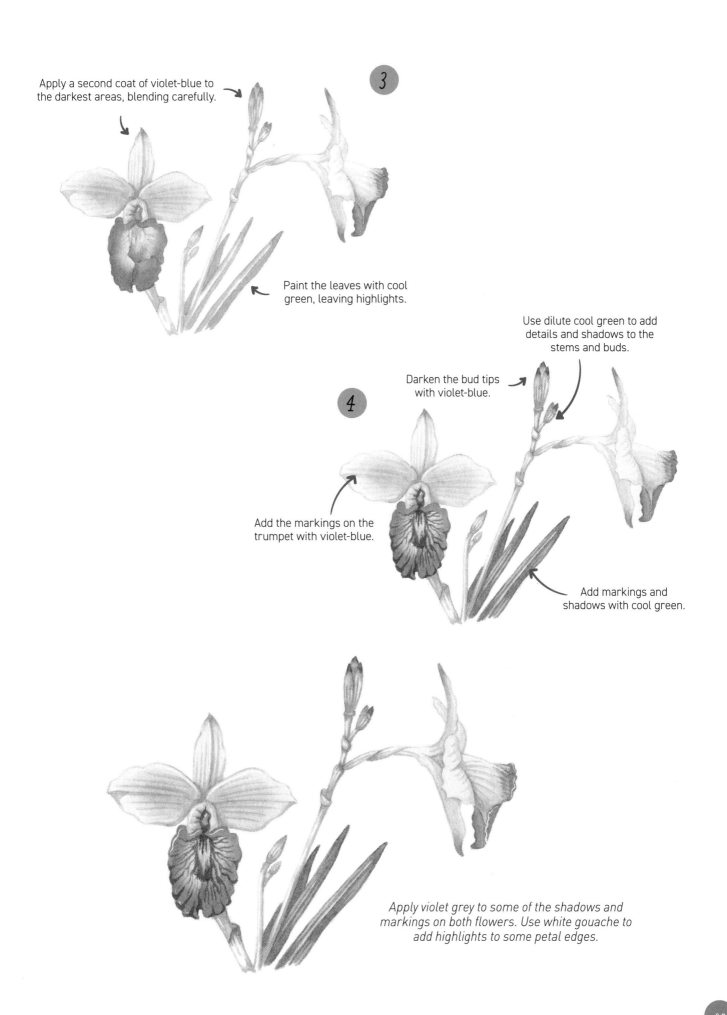

Apply a second coat of violet-blue to the darkest areas, blending carefully.

Paint the leaves with cool green, leaving highlights.

Use dilute cool green to add details and shadows to the stems and buds.

Darken the bud tips with violet-blue.

Add the markings on the trumpet with violet-blue.

Add markings and shadows with cool green.

Apply violet grey to some of the shadows and markings on both flowers. Use white gouache to add highlights to some petal edges.

Siberian Squill

Drawing and colours

Drawing the detailed flower centres accurately is the key to a successful portrayal of this tiny plant.

The watercolour paints you need for this flower are: aureolin, Indian yellow-orange, sap green, cobalt blue, Payne's grey and olive green.

You will also need white gouache paint.

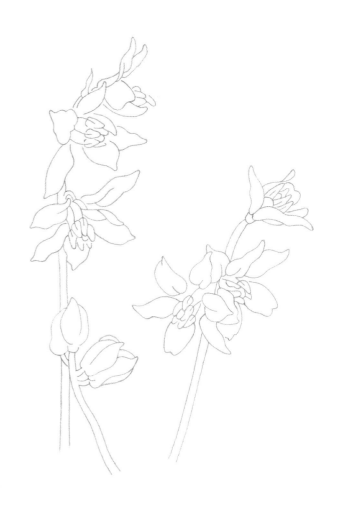

Mixed colours

COOL GREEN
Sap green and cobalt blue

Painting

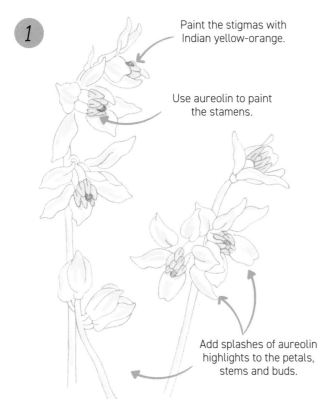

1

Paint the stigmas with Indian yellow-orange.

Use aureolin to paint the stamens.

Add splashes of aureolin highlights to the petals, stems and buds.

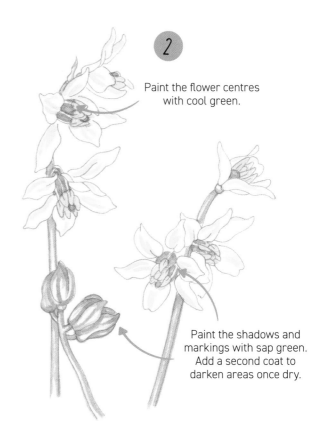

2

Paint the flower centres with cool green.

Paint the shadows and markings with sap green. Add a second coat to darken areas once dry.

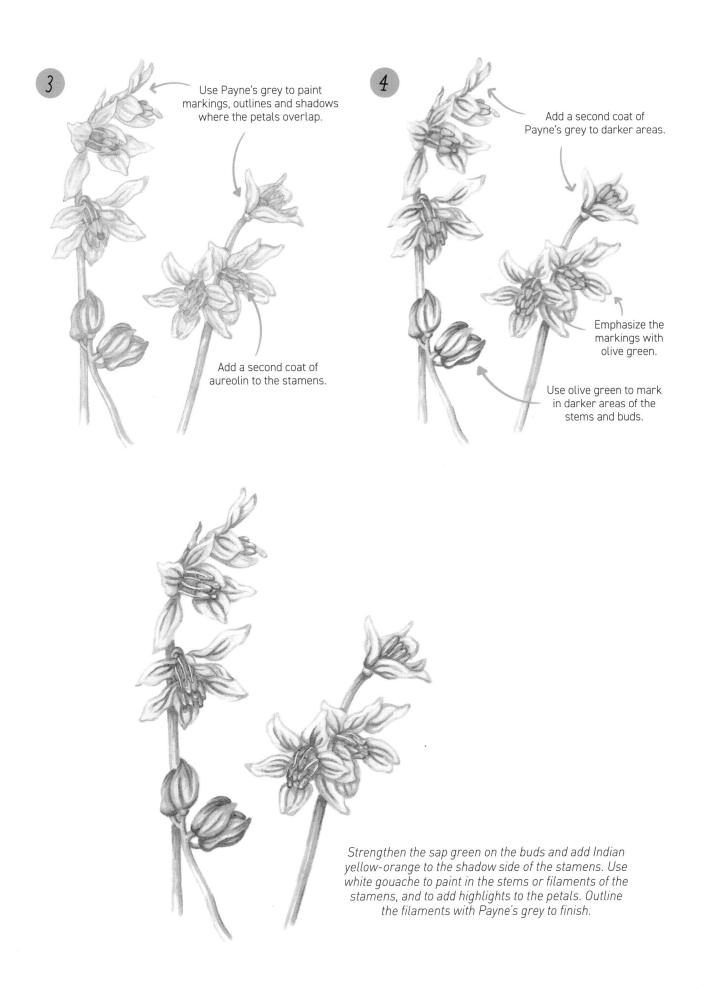

3 Use Payne's grey to paint markings, outlines and shadows where the petals overlap.

Add a second coat of aureolin to the stamens.

4 Add a second coat of Payne's grey to darker areas.

Emphasize the markings with olive green.

Use olive green to mark in darker areas of the stems and buds.

Strengthen the sap green on the buds and add Indian yellow-orange to the shadow side of the stamens. Use white gouache to paint in the stems or filaments of the stamens, and to add highlights to the petals. Outline the filaments with Payne's grey to finish.

Lotus

Drawing and colours

When painting white flowers, do not overwork them. Always leave plenty of white paper.

The watercolour paints you need for this flower are: sap green, aureolin, Payne's grey, French ultramarine, Indian yellow-orange, green earth, cobalt blue, burnt sienna and sepia.

You will also need white gouache paint.

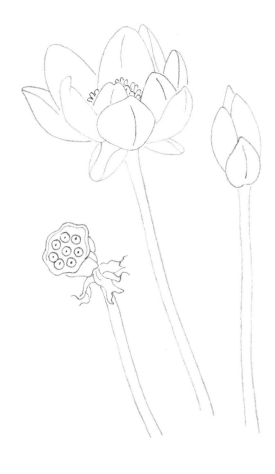

Mixed colours

 COOL GREEN
Sap green and cobalt blue

 STEM GREEN
Sap green and French ultramarine

Painting

Pale wash of sap green for petals, stems, bud and seed head.

Blend the wash on the bud with a clean, damp brush.

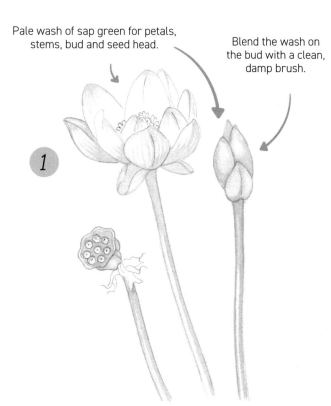

1

Paint the flower centre with aureolin.

Apply a second coat of sap green to strengthen shadows and markings.

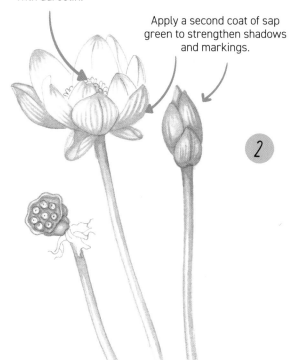

2

Paint shadows and markings with Payne's grey, particularly where petals overlap.

Paint the stamens with Indian yellow-orange.

Add touches of cool green to shade the petals.

Add shading and markings to the bud and seed head with cool green.

3

4

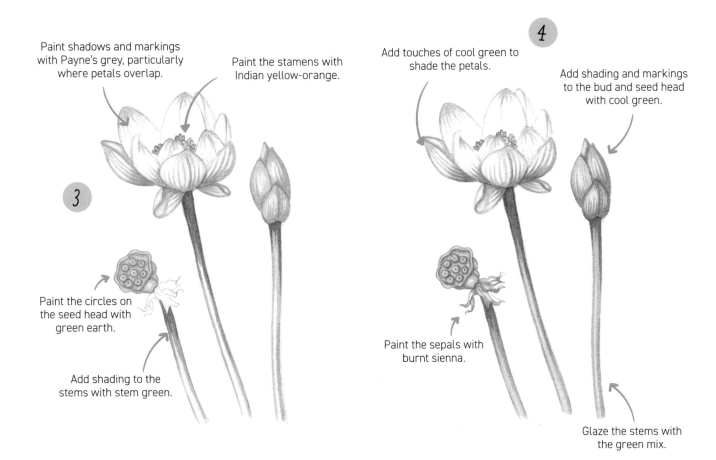

Paint the circles on the seed head with green earth.

Add shading to the stems with stem green.

Paint the sepals with burnt sienna.

Glaze the stems with the green mix.

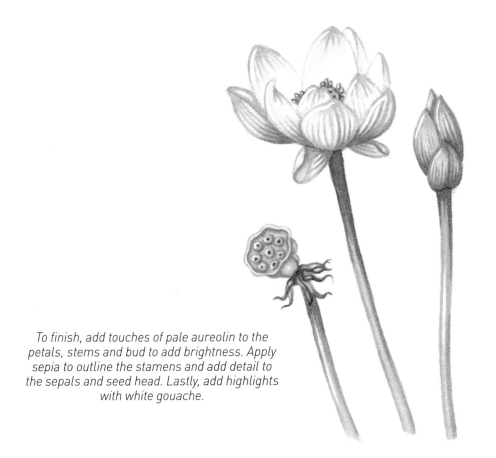

To finish, add touches of pale aureolin to the petals, stems and bud to add brightness. Apply sepia to outline the stamens and add detail to the sepals and seed head. Lastly, add highlights with white gouache.

Pasqueflower

Drawing and colours

When drawing these flowers, make sure that the stems follow through to the flower centres.

The watercolour paints you need for this flower are: bright violet, yellow ochre, cadmium lemon yellow, permanent rose, Indian red, alizarin crimson lake, dioxazine mauve, sap green and cobalt blue.

You will also need white gouache paint.

Mixed colours

LEAF RED
Indian red and alizarin crimson lake

COOL GREEN
Sap green and cobalt blue

DEEP PURPLE
Bright violet and dioxazine mauve

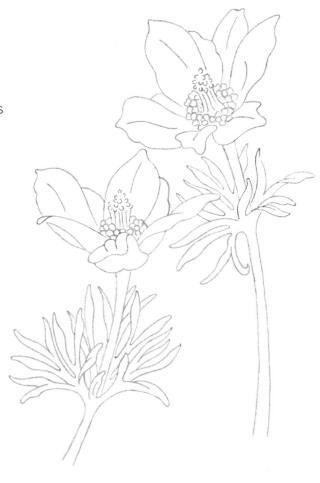

Painting

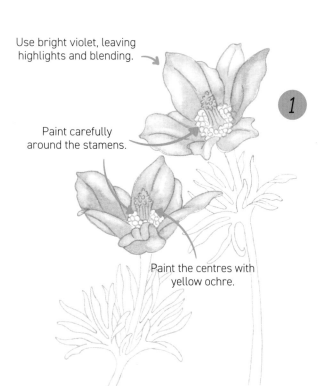

Use bright violet, leaving highlights and blending.

Paint carefully around the stamens.

1

Paint the centres with yellow ochre.

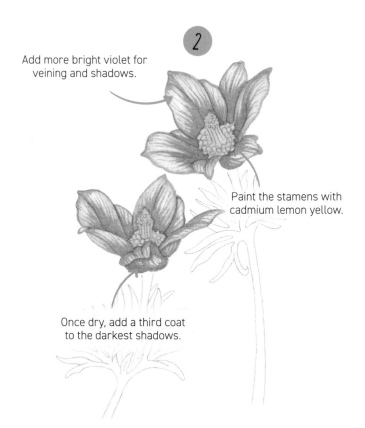

Add more bright violet for veining and shadows.

2

Paint the stamens with cadmium lemon yellow.

Once dry, add a third coat to the darkest shadows.

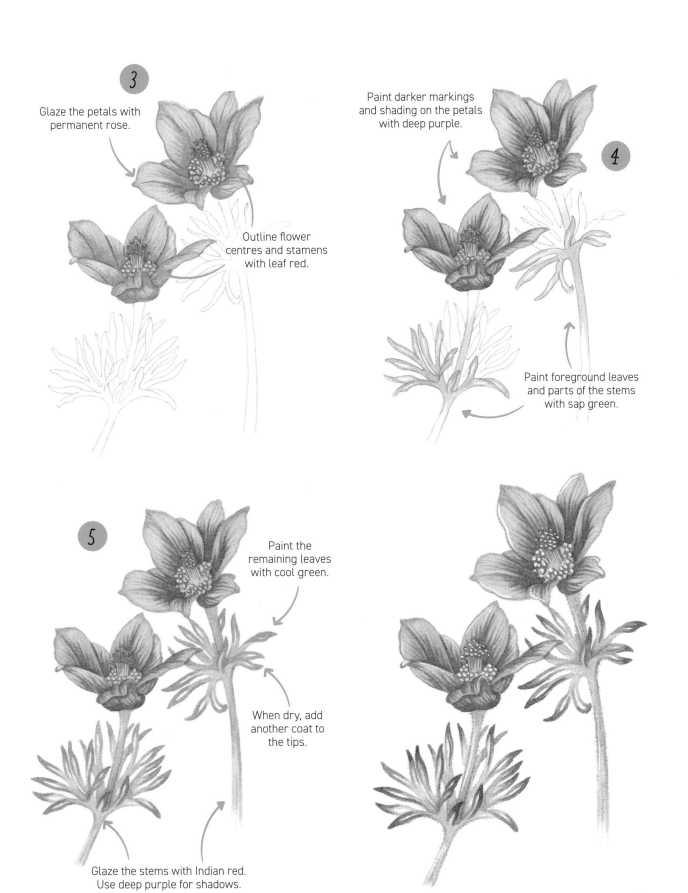

3

Glaze the petals with permanent rose.

Outline flower centres and stamens with leaf red.

Paint darker markings and shading on the petals with deep purple.

4

Paint foreground leaves and parts of the stems with sap green.

5

Paint the remaining leaves with cool green.

When dry, add another coat to the tips.

Glaze the stems with Indian red. Use deep purple for shadows.

Paint the leaf veins and tips with strong cool green. Use white gouache to add highlights to the flower centres, petals and stems. Draw tiny hairs onto the stems and some leaves with a very sharp pencil, taking care to vary the marks.

Chicory

Drawing and colours

Use a small brush with a fine point to paint all the intricate details of the buds and flower centres.

The watercolour paints you need for this flower are: cobalt blue, magenta, sap green, permanent rose, chromium oxide, indanthrene blue and Indian red.

You will also need white gouache paint.

Mixed colours

 MID BLUE
Cobalt blue and magenta

 COOL GREEN
Sap green and cobalt blue

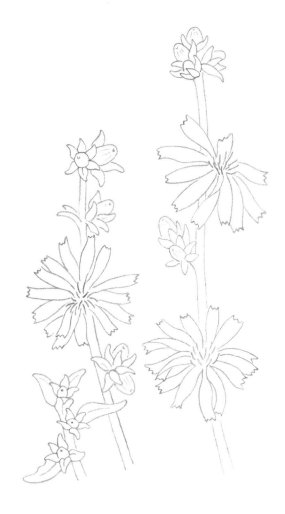

Painting

Paint petals and tips of the larger buds with mid blue, leaving highlights.

1

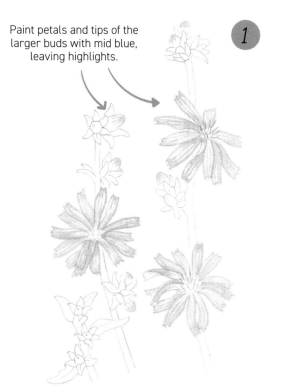

Paint the stems with cool green.

2

Don't miss the little bits between the petals.

Strengthen markings and shadows with mid blue, particularly where petals overlap.

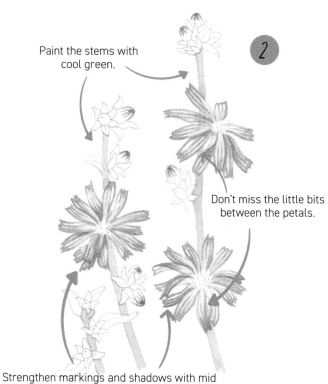

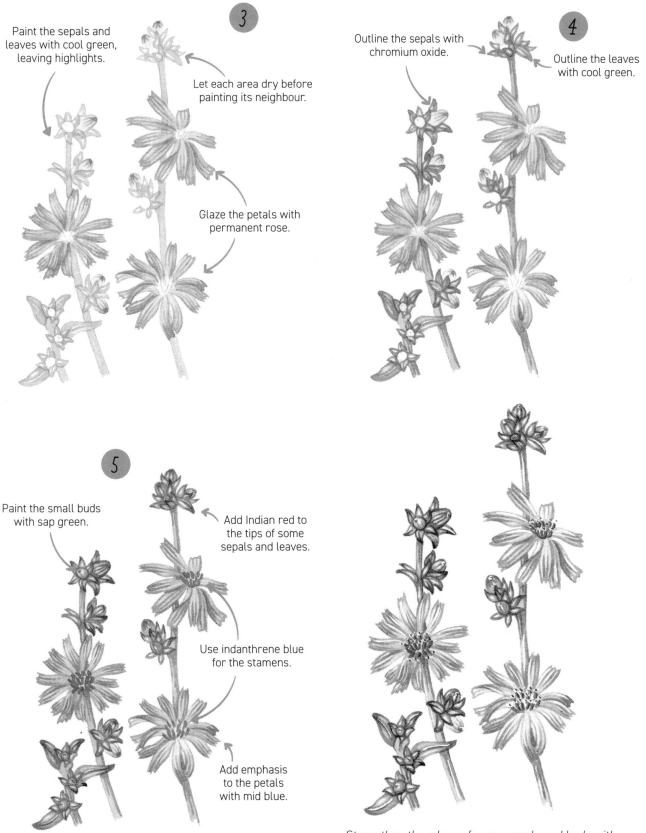

3

Paint the sepals and leaves with cool green, leaving highlights.

Let each area dry before painting its neighbour.

Glaze the petals with permanent rose.

4

Outline the sepals with chromium oxide.

Outline the leaves with cool green.

5

Paint the small buds with sap green.

Add Indian red to the tips of some sepals and leaves.

Use indanthrene blue for the stamens.

Add emphasis to the petals with mid blue.

Strengthen the edges of some sepals and buds with chromium oxide. Use white gouache to add highlights to the petals, buds, leaves and stems. Paint the V-shape at the top of the stamens with white gouache. Outline the stamens with indanthrene blue and add dots to their tops.

Magnolia

Drawing and colours

These are dramatic flowers, and the purple markings help to describe the shapes and curves of the petals.

The watercolour paints you need for this flower are: cadmium red light, French ultramarine, magenta, yellow ochre, sap green, sepia, chromium oxide, golden green and dioxazine mauve.

You will also need white gouache paint.

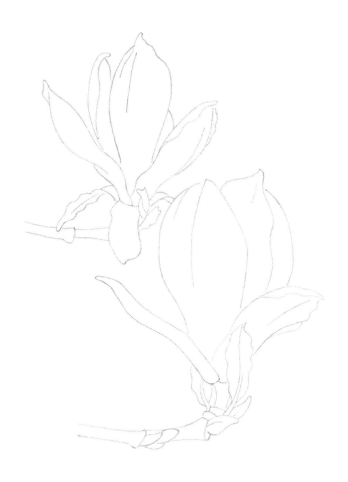

Mixed colours

BOTANICAL GREY
Cadmium red light and French ultramarine

Painting

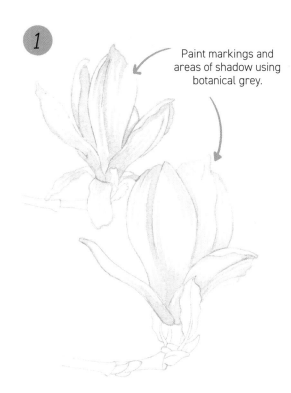

1 Paint markings and areas of shadow using botanical grey.

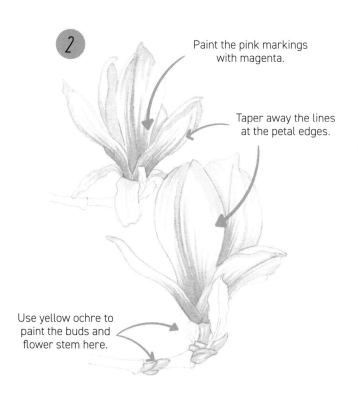

2 Paint the pink markings with magenta.

Taper away the lines at the petal edges.

Use yellow ochre to paint the buds and flower stem here.

3

Apply a second coat of magenta. Don't cover all the earlier layer.

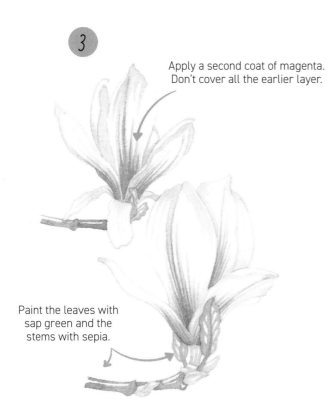

Paint the leaves with sap green and the stems with sepia.

4

Apply more botanical grey to the areas of darkest shadow.

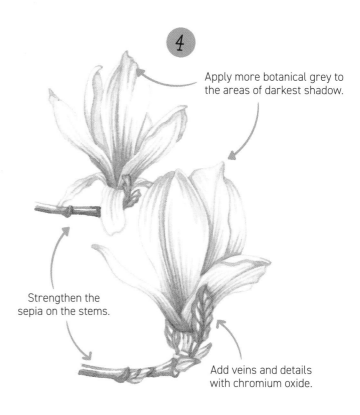

Strengthen the sepia on the stems.

Add veins and details with chromium oxide.

5

Add touches of dioxazine mauve to the bases.

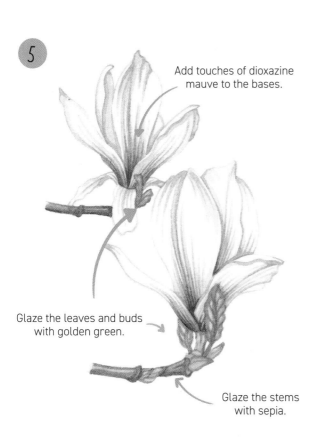

Glaze the leaves and buds with golden green.

Glaze the stems with sepia.

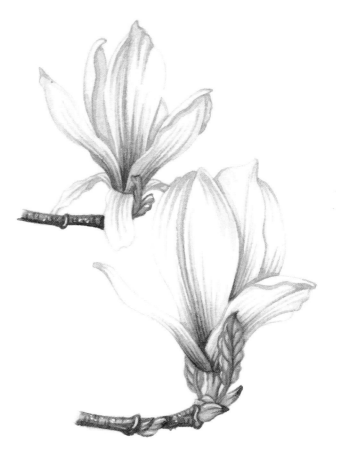

Add detail to the stems with sepia and paint the tips of the buds and the leaf veins with chromium oxide. Use white gouache to add highlights and speckles on the stems.

Geranium

Drawing and colours

Take care to paint carefully around the stamens as the flower centres are very dark.

The watercolour paints you need for this flower are: alizarin crimson, dioxazine mauve, permanent rose, magenta, carmine lake, sap green, yellow ochre, Indian yellow-orange, French ultramarine and burnt sienna.

You will also need white gouache paint.

Mixed colours

 WARM PURPLE
Alizarin crimson and dioxazine mauve

 MAGENTA PINK
Magenta and carmine lake

 STEM GREEN
Sap green and French ultramarine

Painting

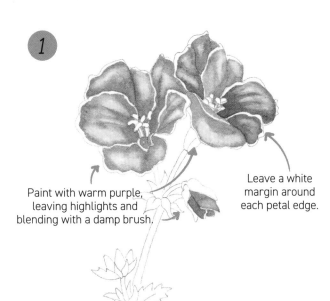

1

Paint with warm purple, leaving highlights and blending with a damp brush.

Leave a white margin around each petal edge.

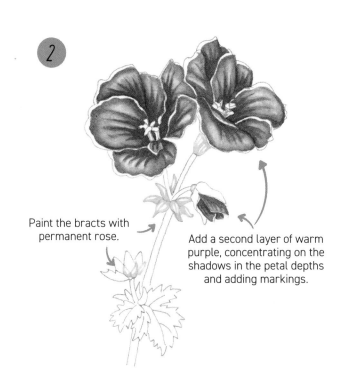

2

Paint the bracts with permanent rose.

Add a second layer of warm purple, concentrating on the shadows in the petal depths and adding markings.

Glaze the petals and bud
with magenta pink.

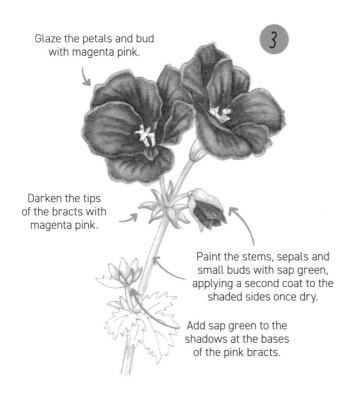

Darken the tips
of the bracts with
magenta pink.

Paint the stems, sepals and
small buds with sap green,
applying a second coat to the
shaded sides once dry.

Add sap green to the
shadows at the bases
of the pink bracts.

Strengthen the shadows and
markings in the flower centres
with warm purple.

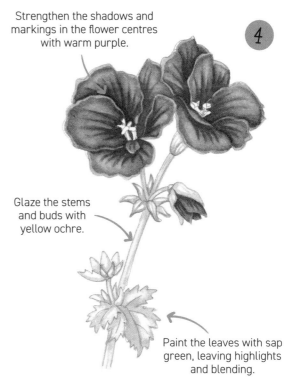

Glaze the stems
and buds with
yellow ochre.

Paint the leaves with sap
green, leaving highlights
and blending.

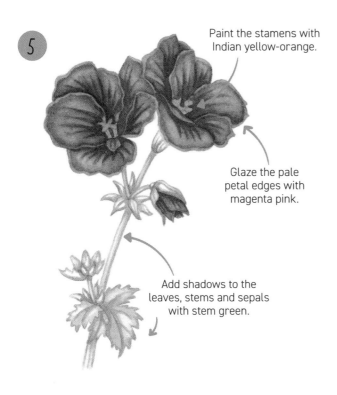

Paint the stamens with
Indian yellow-orange.

Glaze the pale
petal edges with
magenta pink.

Add shadows to the
leaves, stems and sepals
with stem green.

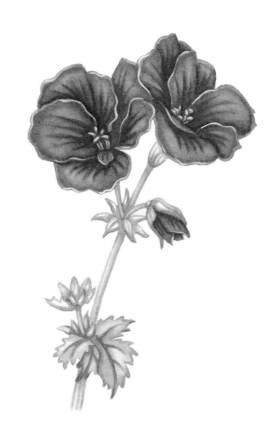

*To finish, outline the stamens with burnt sienna and add
highlights with white gouache. Add highlights to the petal
edges with white gouache.*

Opium Poppy

Drawing and colours

Take care to draw and paint all the little crinkles in the petals of these poppies, as they give the plant its character.

The watercolour paints you need for this flower are: bright violet, cobalt blue, aureolin, quinacridone violet, green earth, cyan, alizarin crimson lake, yellow ochre and burnt sienna.

You will also need white gouache paint.

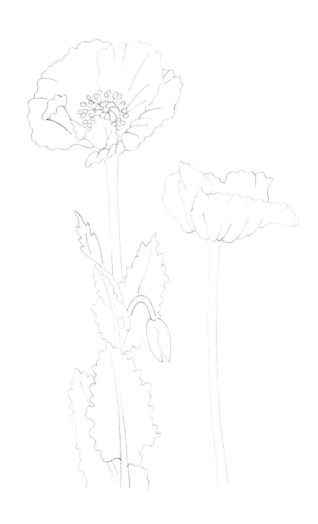

Mixed colours

RED-PURPLE
Bright violet and alizarin crimson lake

COLD GREEN
Green earth and cyan

Painting

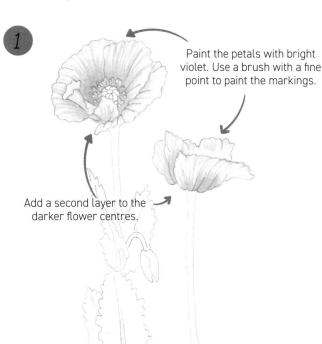

1

Paint the petals with bright violet. Use a brush with a fine point to paint the markings.

Add a second layer to the darker flower centres.

Paint shadows on the petals with a pale wash of cobalt blue.

2

Concentrate the shadows in areas where petals overlap and markings on petal edges.

Paint the stems and bud with aureolin.

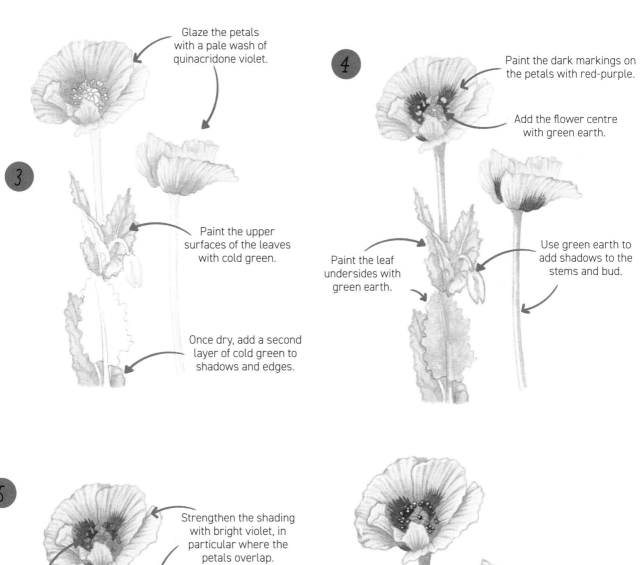

Glaze the petals with a pale wash of quinacridone violet.

3

Paint the upper surfaces of the leaves with cold green.

Once dry, add a second layer of cold green to shadows and edges.

4

Paint the dark markings on the petals with red-purple.

Add the flower centre with green earth.

Paint the leaf undersides with green earth.

Use green earth to add shadows to the stems and bud.

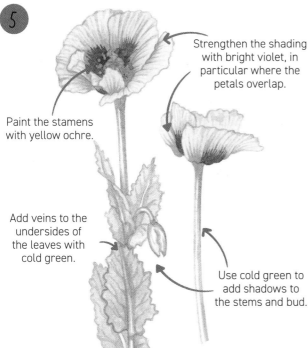

5

Strengthen the shading with bright violet, in particular where the petals overlap.

Paint the stamens with yellow ochre.

Add veins to the undersides of the leaves with cold green.

Use cold green to add shadows to the stems and bud.

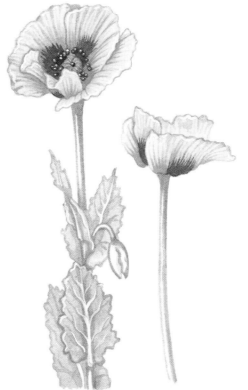

For the finishing touches, outline the stamens with burnt sienna. Use white gouache to add highlights to the stamens, flower centre, petals, stems and leaves. Add veins to some of the leaves with white gouache.

Rose Mallow

Drawing and colours

The flowers on this plant are huge, often reaching the size of dinner plates, and the stripes are distinctive – use the central petal lines on the drawing to help when placing the painted stripes.

The watercolour paints you need for this flower are: magenta, cobalt blue, sap green, permanent rose, yellow ochre and burnt sienna.

You will also need white gouache paint.

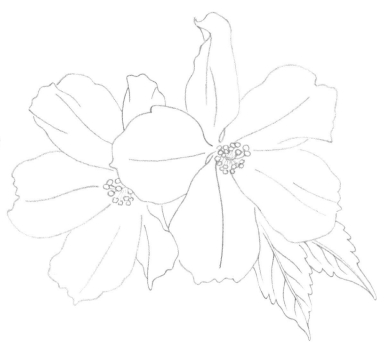

Mixed colours

COOL GREEN
Sap green and cobalt blue

Painting

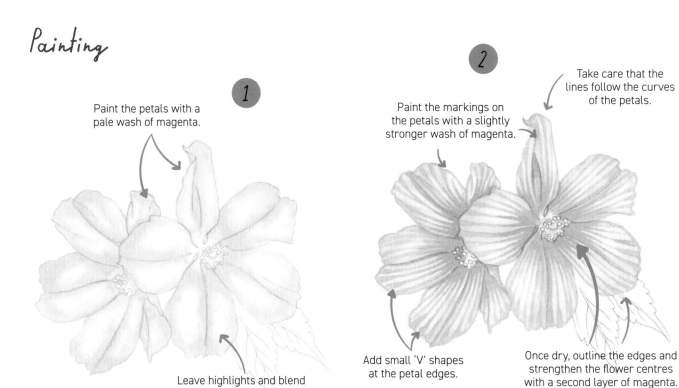

1

Paint the petals with a pale wash of magenta.

Leave highlights and blend with a damp brush.

2

Paint the markings on the petals with a slightly stronger wash of magenta.

Take care that the lines follow the curves of the petals.

Add small 'V' shapes at the petal edges.

Once dry, outline the edges and strengthen the flower centres with a second layer of magenta.

3

Paint the shadows in the flower centres and the 'V' shapes with a pale wash of cobalt blue.

Paint the leaves with cool green, adding a second coat to the shaded side once dry.

4

Glaze the petals with permanent rose.

Add veins and shadows to the leaves with cool green.

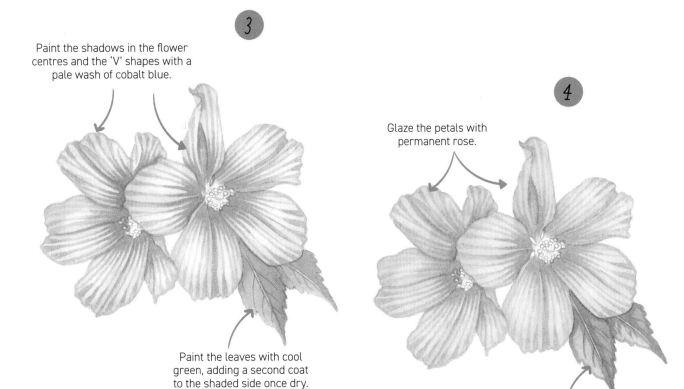

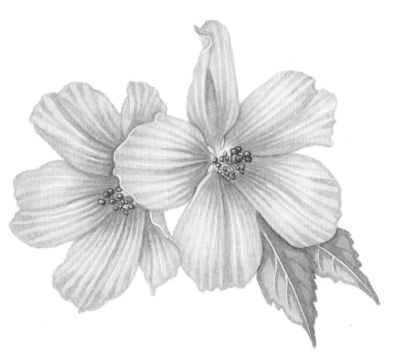

Paint the stamens with strong yellow ochre, outline them with burnt sienna and add highlights with white gouache. Use the white gouache to paint veins on the leaves and add highlights to the petals. Lastly, add touches of cobalt blue to the shadows in the flower centres.

Salsify

Drawing and colours

This flower is only open in the morning, and withers by midday. Because of this, it is also called 'Jack-go-to-bed-at-noon'.

The watercolour paints you need for this flower are: bright violet, cobalt blue, quinacridone violet, yellow ochre, sap green and dioxazine mauve.

You will also need white and yellow gouache paint.

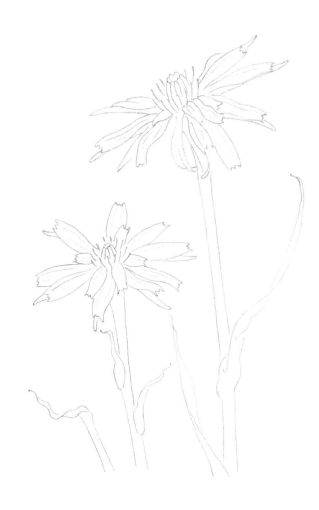

Mixed colours

 RED-GREY
Bright violet and cobalt blue

 COOL GREEN
Sap green and cobalt blue

Painting

Paint the petals with red-grey, leaving highlights.

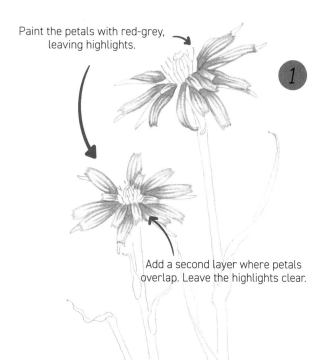

1

Add a second layer where petals overlap. Leave the highlights clear.

2

Outline the flower centre with red-grey.

Glaze the petals with quinacridone violet.

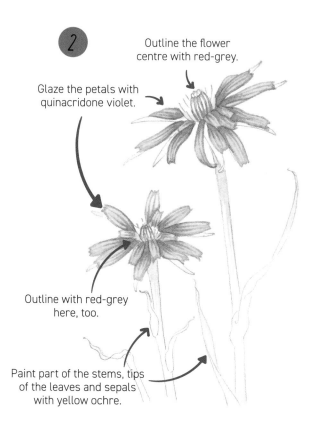

Outline with red-grey here, too.

Paint part of the stems, tips of the leaves and sepals with yellow ochre.

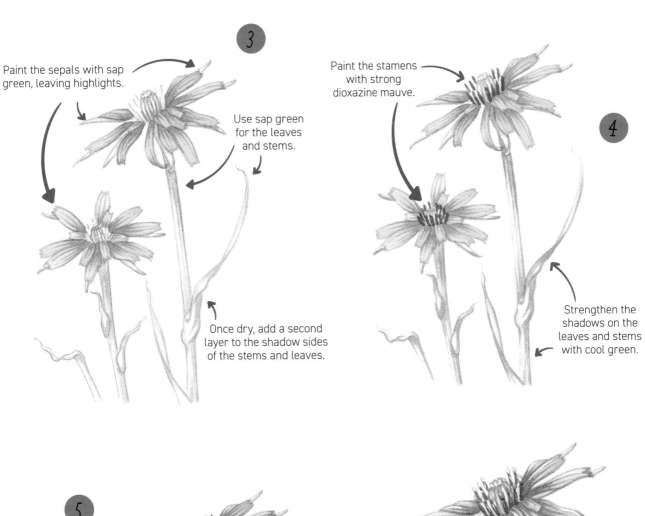

3

Paint the sepals with sap green, leaving highlights.

Use sap green for the leaves and stems.

Once dry, add a second layer to the shadow sides of the stems and leaves.

4

Paint the stamens with strong dioxazine mauve.

Strengthen the shadows on the leaves and stems with cool green.

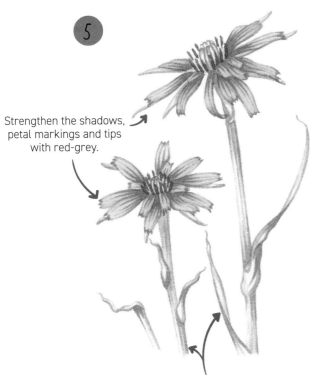

5

Strengthen the shadows, petal markings and tips with red-grey.

Use red-grey to deepen the darkest areas of the leaves and to add colour to their tips.

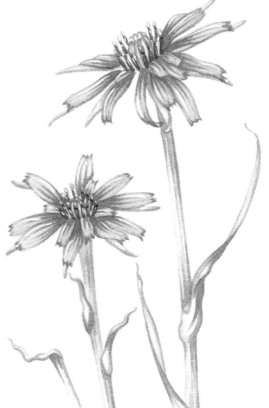

To finish, paint the tips of the stamens with yellow gouache, then paint highlights on the petals and stamens with white gouache.

Hibiscus

Drawing and colours

As this is a flower that is pale in colour, remember to erase the pencil lines slightly before painting so that they are not too visible.

The watercolour paints you need for this flower are: violet grey, permanent rose, sap green, cobalt blue, dioxazine mauve, cadmium red light, cadmium lemon yellow and yellow ochre.

You will also need white gouache paint.

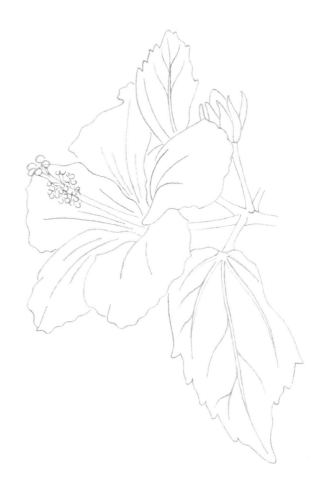

Mixed colours

 COOL GREEN
Sap green and cobalt blue

Painting

Use violet grey to paint lines that follow the curves of the petals and outline the edges.

1

Paint the small wedge-shaped shadows at the petal edges.

Apply a second layer once dry to strengthen the colour and the shadows.

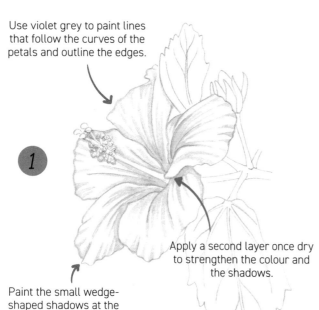

2

Paint the markings with permanent rose.

Paint the buds and stems with two wet on dry layers of sap green, applying the second layer to the shadows.

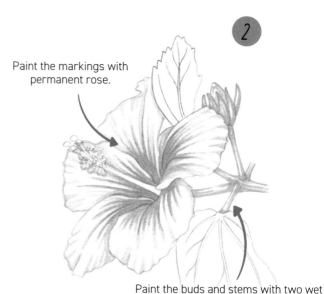

Glaze with a very pale wash of permanent rose.

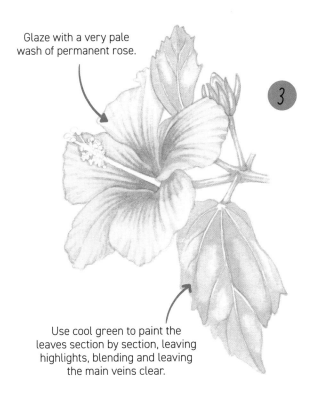

3

Use cool green to paint the leaves section by section, leaving highlights, blending and leaving the main veins clear.

4

Apply another layer of permanent rose to the flower centre markings.

Add shadows and details to the bud and stems with cool green.

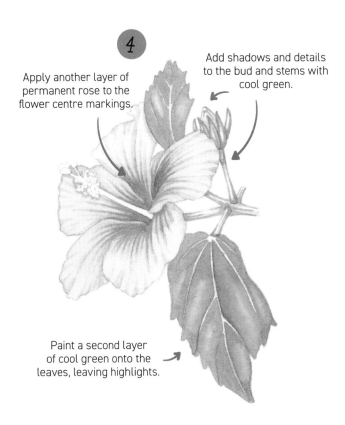

Paint a second layer of cool green onto the leaves, leaving highlights.

5

Paint the stamens with cadmium red light and cadmium lemon yellow, and the style with yellow ochre.

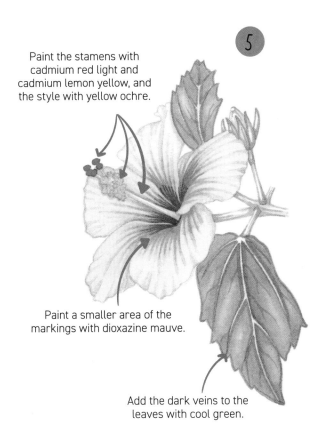

Paint a smaller area of the markings with dioxazine mauve.

Add the dark veins to the leaves with cool green.

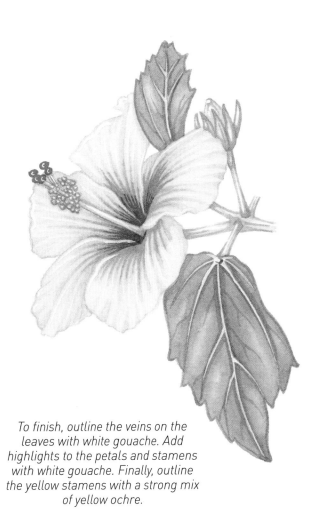

To finish, outline the veins on the leaves with white gouache. Add highlights to the petals and stamens with white gouache. Finally, outline the yellow stamens with a strong mix of yellow ochre.

Cannonball Tree

Drawing and colours

Draw the snake-like stamens of this strange flower carefully. The name comes from the huge fruits which truly are the shape and size of cannonballs.

The watercolour paints you need for this flower are: Indian yellow-orange, carmine lake, permanent rose, golden green and chromium oxide.

You will also need yellow and white gouache paints.

Mixed colours

 RED-ORANGE
Indian yellow-orange and carmine lake

Painting

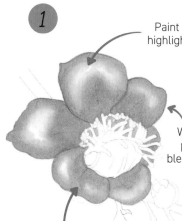

1

Paint with red-orange. Leave a highlight on each petal and blend.

Work in sections: apply the paint to half the petal and blend, then paint the other half.

Once dry, apply a second layer to strengthen the colour.

2

Glaze with a mid strength wash of permanent rose.

Paint the stamens with permanent rose, leaving a white strip on the light side.

Paint the lip-like structure with two layers of permanent rose, wet on dry, curving the lines around the shape.

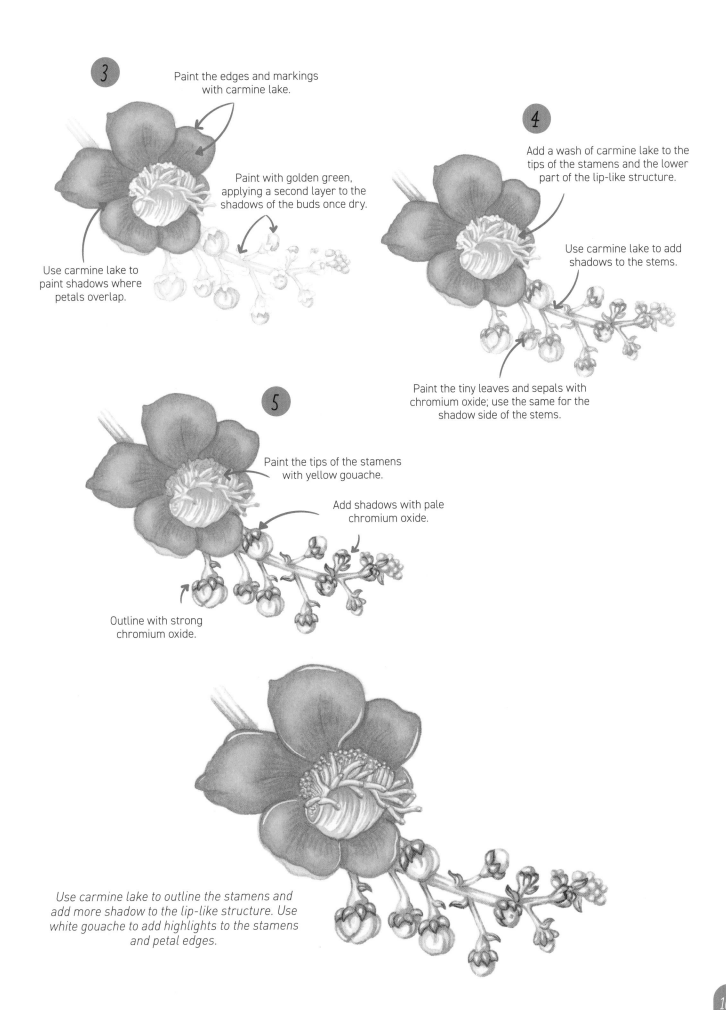

3

Paint the edges and markings with carmine lake.

Paint with golden green, applying a second layer to the shadows of the buds once dry.

Use carmine lake to paint shadows where petals overlap.

4

Add a wash of carmine lake to the tips of the stamens and the lower part of the lip-like structure.

Use carmine lake to add shadows to the stems.

Paint the tiny leaves and sepals with chromium oxide; use the same for the shadow side of the stems.

5

Paint the tips of the stamens with yellow gouache.

Add shadows with pale chromium oxide.

Outline with strong chromium oxide.

Use carmine lake to outline the stamens and add more shadow to the lip-like structure. Use white gouache to add highlights to the stamens and petal edges.

Foxglove

Drawing and colours

The dark patterning on the inside of the trumpets is particularly fun to paint.

The watercolour paints you need for this flower are: magenta, cobalt blue, cadmium lemon yellow, sap green, alizarin crimson lake and dioxazine mauve.

You will also need white gouache paint.

Mixed colours

COOL GREEN
Sap green and cobalt blue

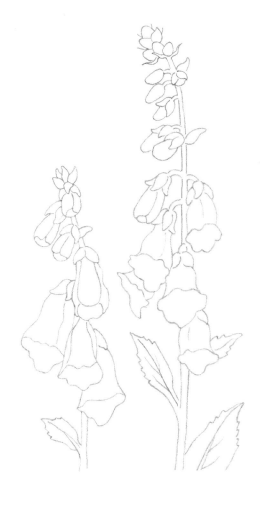

Painting

1

Paint the larger flowers with magenta, leaving highlights and blending.

Once dry, add a second layer to areas of shadow.

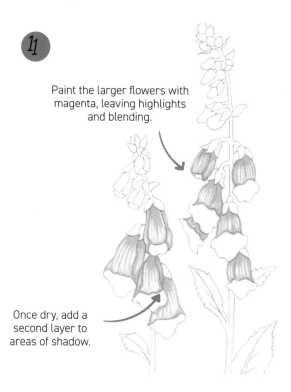

2

Apply a pale wash of magenta to the small buds and the inner petals of the trumpets.

Paint shadows onto all the petals and buds with a pale wash of cobalt blue.

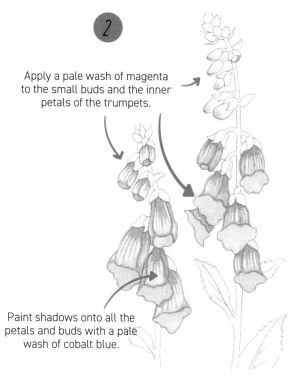

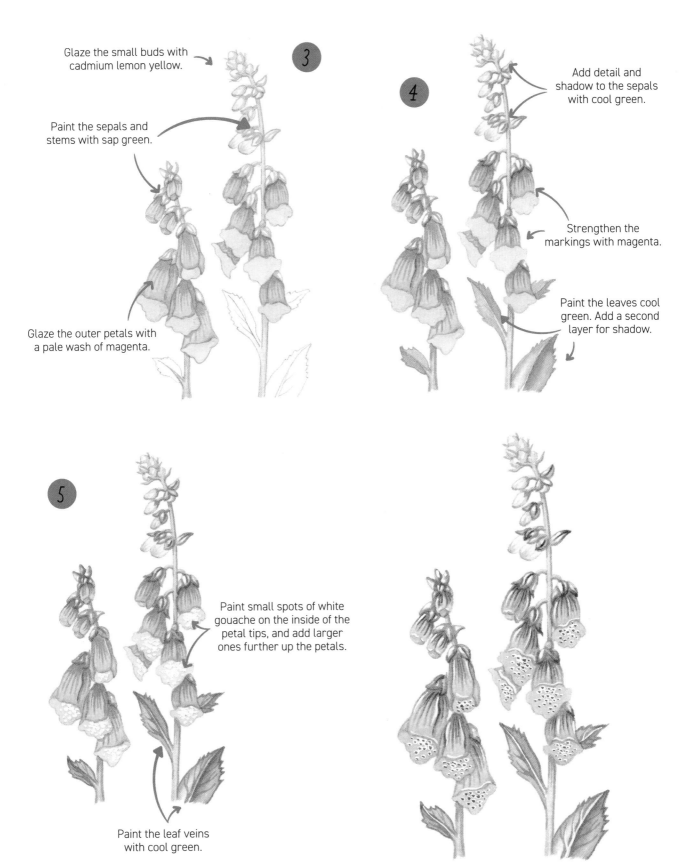

3

Glaze the small buds with cadmium lemon yellow.

Paint the sepals and stems with sap green.

Glaze the outer petals with a pale wash of magenta.

4

Add detail and shadow to the sepals with cool green.

Strengthen the markings with magenta.

Paint the leaves cool green. Add a second layer for shadow.

5

Paint small spots of white gouache on the inside of the petal tips, and add larger ones further up the petals.

Paint the leaf veins with cool green.

Paint the markings on the inner petals with alizarin crimson lake. Darken some markings and details on the petals and sepals with dioxazine mauve. Add highlights to the petals, sepals and leaf veins with white gouache.

Corsage Orchid

Drawing and colours

Take care to draw all the crinkles and curves very carefully as they give the flower its unique character.

The watercolour paints you need for this flower are: cadmium red light, Indian yellow-orange, chromium oxide, red gold lake and olive green.

You will also need white gouache paint.

Mixed colours

 SUNNY ORANGE
Cadmium red light and Indian yellow-orange

Painting

1

Paint the petals with sunny orange, leaving highlights and blending.

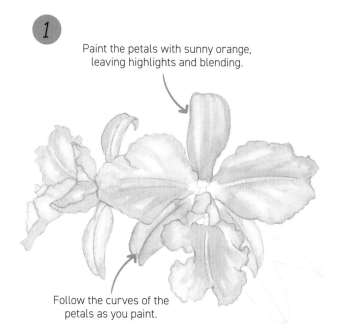

Follow the curves of the petals as you paint.

2

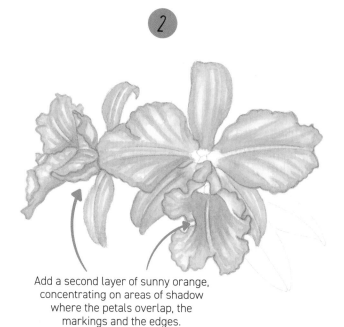

Add a second layer of sunny orange, concentrating on areas of shadow where the petals overlap, the markings and the edges.

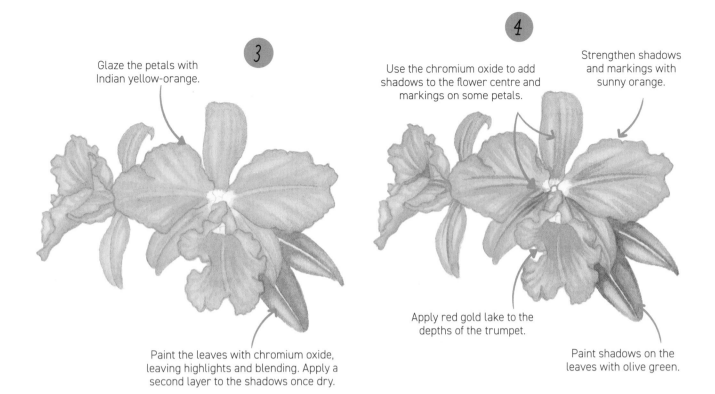

3

Glaze the petals with Indian yellow-orange.

Paint the leaves with chromium oxide, leaving highlights and blending. Apply a second layer to the shadows once dry.

4

Use the chromium oxide to add shadows to the flower centre and markings on some petals.

Strengthen shadows and markings with sunny orange.

Apply red gold lake to the depths of the trumpet.

Paint shadows on the leaves with olive green.

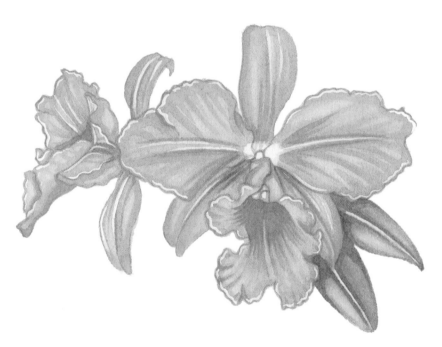

Paint the centre of the trumpet with cadmium red light, tapering the lines as they approach the petal edges. Use the red to strengthen some markings on the rest of the petals. Apply highlights to the petal centres, the petal edges and the leaves with white gouache.

PAINT 50 WATERCOLOUR FLOWERS

Acknowledgments

Thank you to all at Search Press, especially my editor Edward Ralph, and to Samantha Warrington, for all their help and encouragement. Also, thank you to the natural world for providing such a wealth of inspiration.

Dedication

To my grandsons, Oliver and Theo.

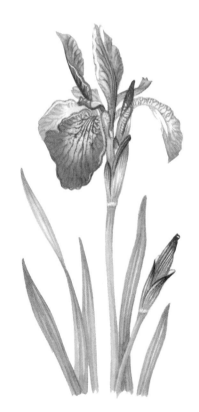

First published in 2024

Search Press Limited
Wellwood, North Farm Road,
Tunbridge Wells, Kent TN2 3DR

ISBN: 978-1-80092-120-7
ebook ISBN: 978-1-80093-109-1

Suppliers

If you have difficulty in obtaining any of the materials and equipment mentioned in this book, then please visit the Search Press website for details of suppliers: www.searchpress.com

Extra copies of the line drawings are also available to download free from Bookmarked: www.bookmarkedhub.com

Search for this book by title or ISBN: the files can be found under 'Book Extras'. Membership of the Bookmarked online community is free.

MIX
Paper | Supporting responsible forestry
FSC® C020056
FSC
www.fsc.org